6/21/15

Happy Birthday, John
___ & Christie
___ look as
___ your
___ & your
observe LIFE & the
starry Heavens!
Love,
Mom

Shhhhh.

Dedicated to Roxanne Quimby and the folks at The Quimby Family Foundation
for nurturing creativity in the Maine woods.

The Gentle Whisper of Living Things

Michael Weymouth

> *"Turn away from the folly of human pursuits and return to one's natural wellspring."*
> Lao Tzu

The Ten Thousand Things

My earliest memories of the woods are of a dark and mysterious and sometimes fearful place that stood like a closed door at the edge of fields and roadsides. It was a world one entered only at one's peril. As time passed, the door gradually opened, as youthful, self-imposed barriers inevitably do and I soon learned to love the woods. Darkness became light, mystery became magic and fearful corners revealed themselves as nothing more than the dark side of a boy's vivid imagination.

In the ensuing years, and in a more profound sense, I have come to realize that wilderness is not unlike life itself: full of joyful experience but still with its own mysteries and dark corners and always the lurking fear of inevitable death.

Man has dealt with these deep philosophical issues since the beginning of time but one of my favorite travelers in this journey is Lao Tzu, a sixth century B.C. philosopher believed to be the founder of Taoism. In his search for answers to life's mysteries Lao Tzu left the world of man to live alone in the natural world. The result was the *Tao de Ching*. When Lao Tzu reached a point where words could no longer describe what he was thinking and feeling, he lumped all the remaining mystery into the proverbial "ten thousand things," a number that was presumably so high and incomprehensible that rather than try to understand the unresolved mysteries therein, one should just accept them. Nevertheless, I believe Lao Tzu's view of the connectivity of all living things, between the natural world and that of man, was a defining moment in philosophy.

Centuries later Henry David Thoreau made similar journeys, as did other naturalists such as John Muir who famously said, "The clearest way into the universe is through a forest wilderness," a short and pithy way of distilling Lao Tzu's entire philosophy into one simple statement. However, I much prefer Lao Tzu's version mainly because, unlike John Muir who formed his opinions in the visual grandeur of the Sierra Nevada, Lao Tzu spent much more time at ground level, where the natural world exists in all its complexity, danger and beauty and where I believe one is much more likely to find the answers to profound questions.

For my part, and in no way do I compare myself to these great minds, I simply built a camp in the Maine woods, as a way to return to the slower-paced life of my

youth after years in the big city, and also to reconnect with nature and immerse myself in the narrative of the ten thousand things. The camp was not an attempt to go back home again, as some suggested at the time, rather it was the continuation of a journey I had begun in my younger days growing up in Maine, and in particular, the journey that had taken me into the woods.

Building a camp well off the grid is no easy task, but with the help of friends and relatives for whose help I am eternally grateful, the job was more or less finished in six years. After the last nail was driven, I began my sojourns into the surrounding woods. Having spent my professional life as a photographer, it was only natural that I try to capture my experiences through a lens. However it wasn't long before I discovered the obvious: that photography has its limitations. There were simply too many things happening out there: a strand of spider's web spiraling in the moving air as it twirled in the wake of a passing bird; the twin vortex created by a loon's wings as it glided through the morning fog. These were images indelibly imprinted on my mind in part because they were improbable if not impossible to photograph.

One of my favorite visual images took place in a windless woods one winter's day after a pristine snowfall, the quiet kind where every snowflake falls so softly and effortlessly to the ground it retains its original crystalline shape. I was on snowshoes and when I passed from the black growth into an open clearing deep with powder, the snow exploded all around me as though I had been caught in an artillery barrage. A covey of partridge had hunkered down during the storm and had been completely covered by the snow. Hearing the crunching of my snowshoes, the entire flock took flight as one, up through a foot and a half of powder, creating a full-fledged partridge snowstorm. It was one of those unforgettable moments that, for all its magic, took place so quickly and unexpectedly that it defied one's ability to actually photograph it.

The myriad sounds in the woods transcended photography as well: a thrush's beautiful evening song floating through the pines; beavers affectionately chatting to one another in their lodge; the haunting sounds of loons calling from pond to pond in the night.

And then there was the metaphysical experience, which is where I felt the most connection to Lao Tzu: I have sat transfixed as a pond released a mayfly hatch, rendering the air abuzz amongst diving hordes of swallows, and watched as the survivors gathered in the trees along the windward shore to perform their mating dance, copulate and fall to earth: a timeless story of birth, death and rebirth. The cedar grove in which I often sit is also a place of reckoning one's existence and I'm sure I am not the first person to look upon a cedar bone yard and see my own transcendence and feel

the peace therein: we live, we die, we leave something of ourselves behind.

Through Lao Tzu's philosophy I saw in the untimely deaths of trees downed by winter storms a protected haven for new trees to grow, sprouts that quite possibly came from cones dropped by the very same trees that lay twisted and broken in their midst. And in that exchange, I saw the role we all play in procreation: the giving of ourselves so our offspring will survive and flourish.

So many thoughts beyond the power of photography.

So I added pen and paper to my camera bag and started to write as well as to photograph. And an amazing thing happened. Writing gave me another set of eyes that allowed me to see beyond the visual image. For the first time I felt the breeze from a hovering insect on my fingertips and heard the clashing of dragonfly wings. I listened to the silence in the woods after a rain and realized how nature's flock holds its breath in the noisy, dripping woods, all the better to distinguish the footfalls of quietly stalking predators from the rain-induced pitter patter. I listened to the wind pounding the antlered spruce trees along the shore in concert with Beethoven's pastoral symphony playing on the porch, as though he had written it on just such a tumultuous day. Golden grasses waving in a late summer breeze seemed to have their own voice, as did the fiddle head ferns unfurling their violin tops in the spring. Watching a doe quietly feeding in the woods instead of running in fright was like observing a shopper at a farmers market: "Ah, let's see, which of these two heads of lettuce is the freshest?" And then, "Wait, what is that strange shape standing there with a rainbow-tinted circle pointing my way? What is that clicking sound?" And then, as the deer moved on unafraid, I was overcome by the awareness that I was in the presence of one of nature's most beautiful creatures...on her terms, not mine.

As I listened more intently, even inanimate objects spoke to me. The ledge on which my camp was built became a transcendental reminder of time and space. The last glacier had scraped it clean leaving telltale slate dust on the lee side of the ledge as well as ragged slate remnants in its wake, in much the same way a wave washing on a shore or a rushing stream causes objects to move in real time. Seeing oneself in this larger time continuum was strangely reassuring, as though we are all part of a shared journey and not just tiny unconnected specks in the universe.

These and other voices are to be found in *The Gentle Whisper of Living Things:* a collection of my own experiences during the many peaceful hours I've spent watching and listening in the Maine woods and perhaps more profoundly, feeling as Lao Tzu did, that we are one with the natural world and that many of the answers we seek about our own existence can be found there.

Michael Weymouth

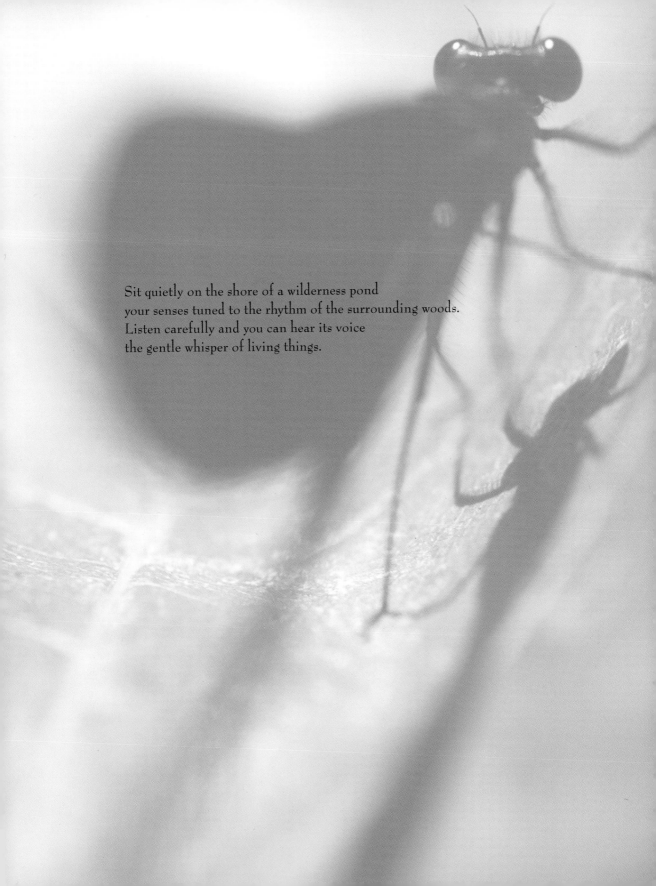

Sit quietly on the shore of a wilderness pond
your senses tuned to the rhythm of the surrounding woods.
Listen carefully and you can hear its voice
the gentle whisper of living things.

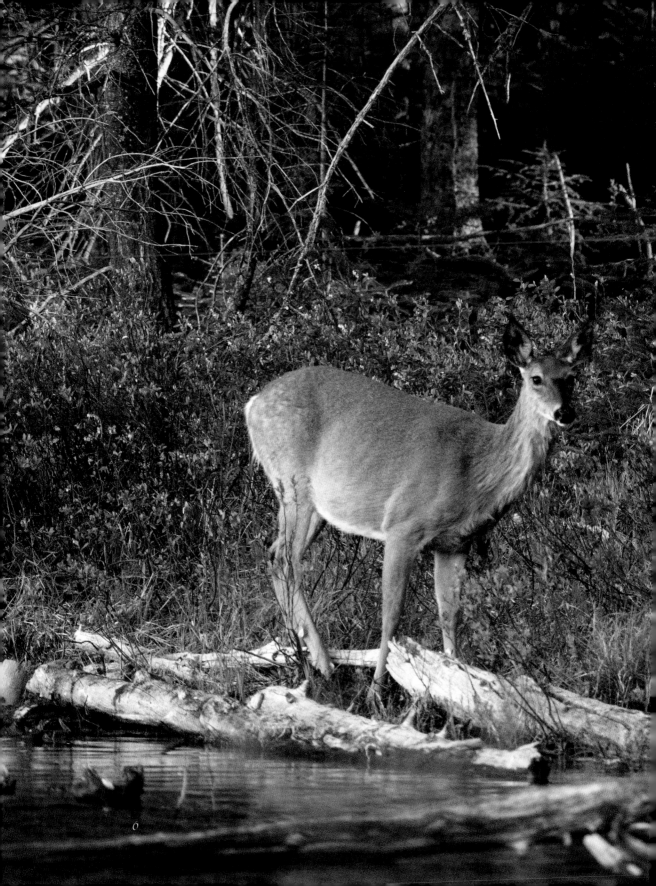

Archipelagoes

Lace caps in bloom
scattered amongst the
gray and leafless beech
tiny archipelagoes of white
floating in a sea of green
blossoms uplifted, reaching out
reveling in the warm sun
rejoicing in winter's end
the coming of spring.

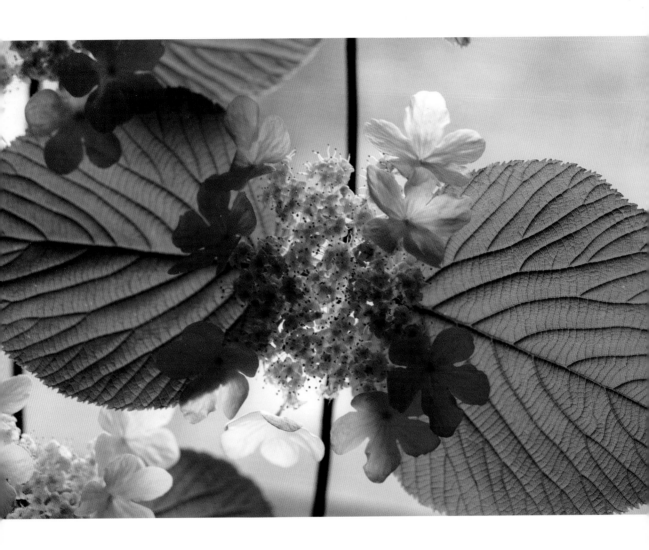

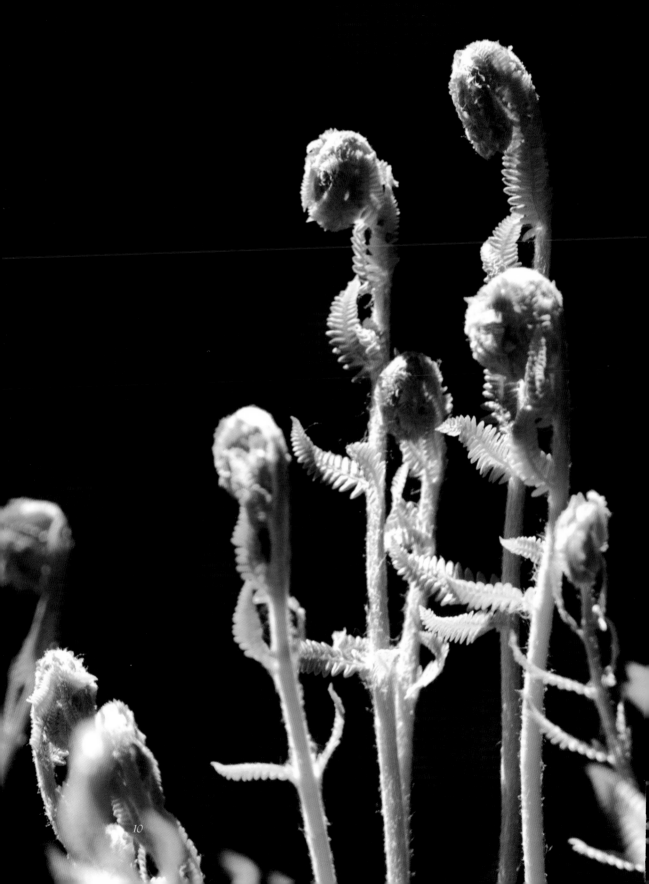

Green

Coiled ferns emerge
through winter-worn leaves
unfurling as they grow

becoming

a quiver of violin, of
viola, cello and bass
nature's spring ensemble

soon

to color the wooded plain
a symphony of fractal green.

Loon seeking mate
Casts rainbow red eye down pond
Displays chiseled profile

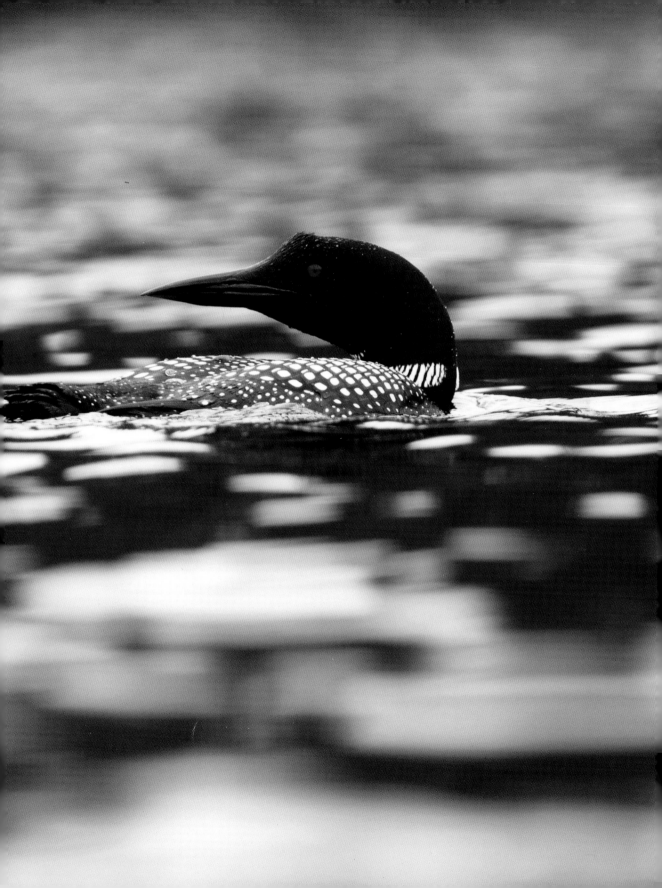

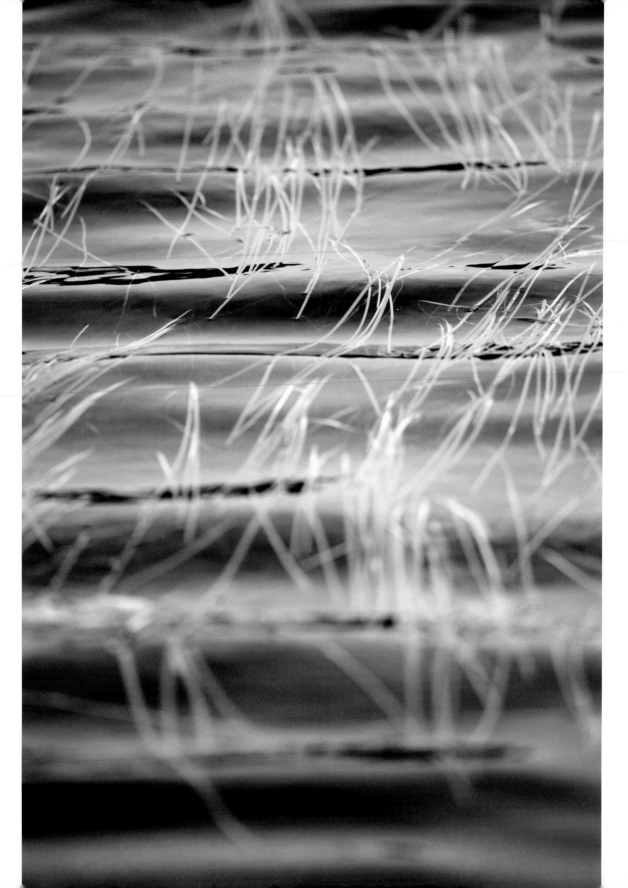

Calligraphy

Suspended grass becomes
rippled brush strokes painted
on reflected blue sky
water's calligraphic canvas.

Listening

It is early evening in the stand
sunlight still lingers in the western sky
painting the woods with flecks of gold
as tall pines, the last to hold the fading light
quietly give up the day.

The time for listening settles in
when eyesight succumbs to gentle sounds:
a cone falling lazily to earth
water lapping rhymes along the shore
loons clucking love songs on the pond.

A wood thrush calls, richly melodious
drifting through the woods from far away
clear and distinct, full of glorious celebration
as if he and he alone owned the air
saying, "listen, I'm singing my song."

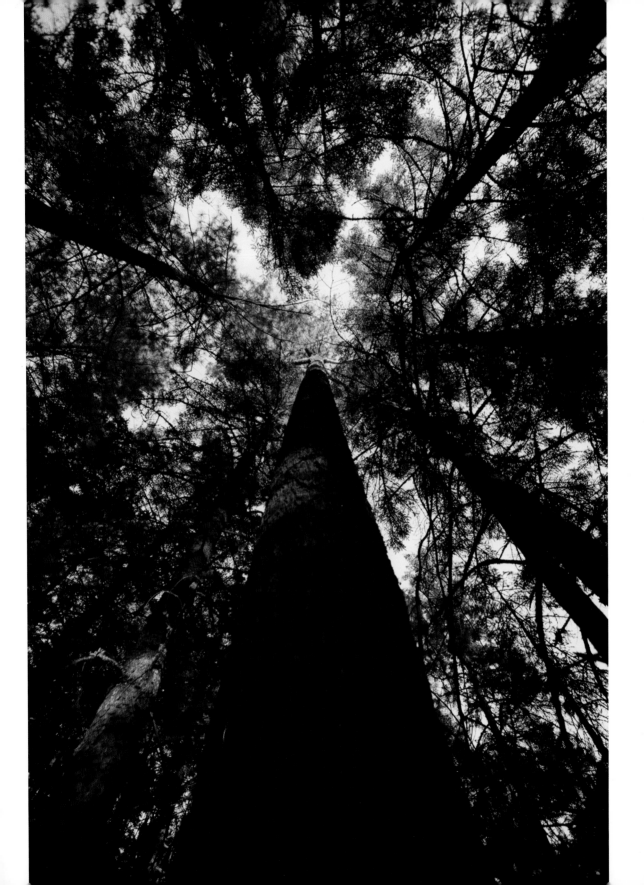

Merganser pair
Synchronized plumage in flight
Feathers walk on water

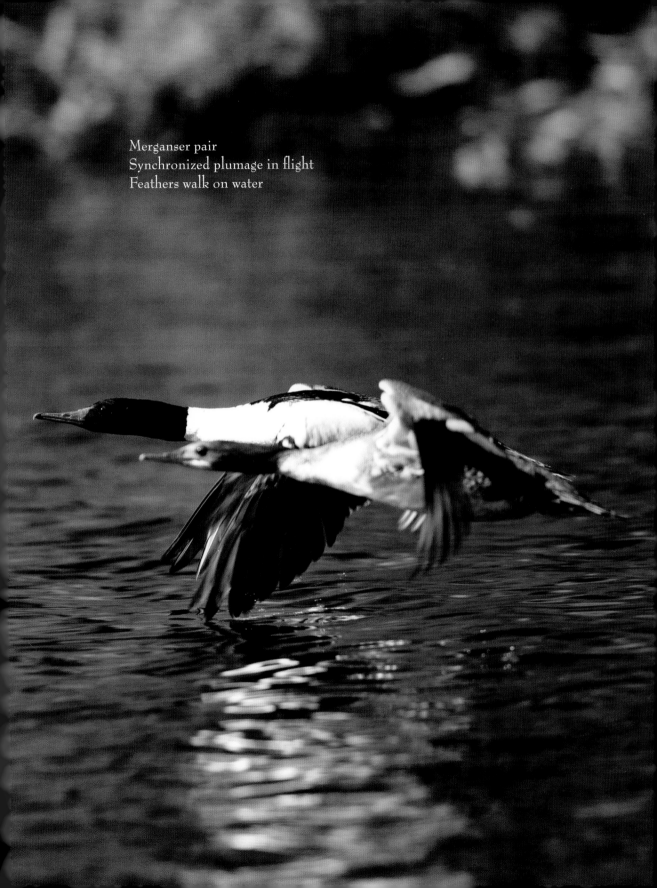

Each spring a white trillium appears at the base of a large pine near my camp. The trillium and I are Darwinian bedfellows insofar as I enjoy its presence while my camp provides protection from its main predator, the white-tailed deer, who does not venture too close to human habitats. Thus the trillium leads a life of relative calm as it graces the view at the end of my porch.

In lieu of foraging deer to spread its seed this trillium propagates with a touch of panache through myrmecochory via corpse-carrying ants, which are attracted to lipids and oleic acids present in the elaiosome at the base of its seed, to form a single, transportable unit called a diaspore. The ants laboriously carry the diaspore back to their colony where the elaiosome is detached and fed to hungry larvae.

The seed is then cast aside and left to germinate in the protective confines of the ant hill's fertile soil.

Those inclined to look skyward for existential answers might take a moment to look to the forest floor - into the nooks and crannies of the natural world - where answers are lying all about for those with eyes and minds to see.

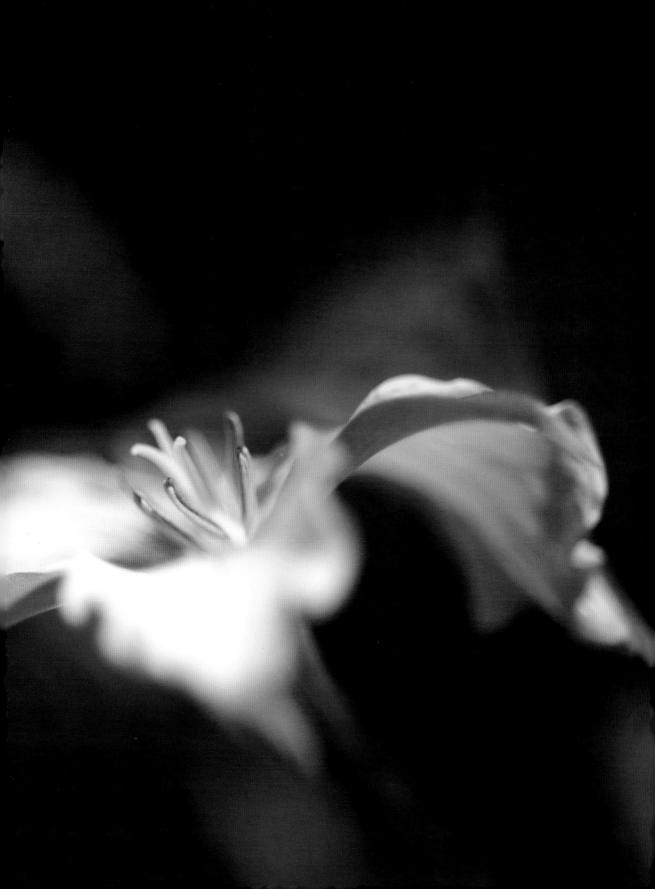

Memories

When I was a young man I walked the trail
in those days it ran along the ridge between the ponds
a route that has long since been left to nature's ways
becoming ever more ragged with each passing year.

Still, I walk the trail as one who wears old shoes
following faded blazes and weathered signs on trees
reminders of my youth, that memories, like these markings
are the signposts on the long journey of our lives.

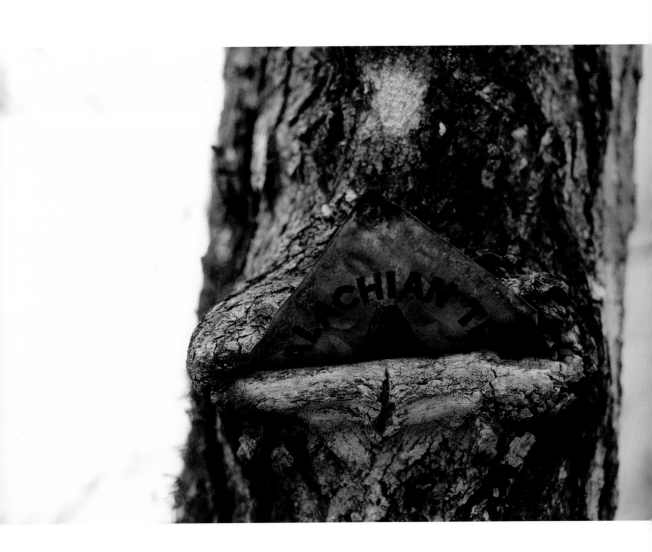

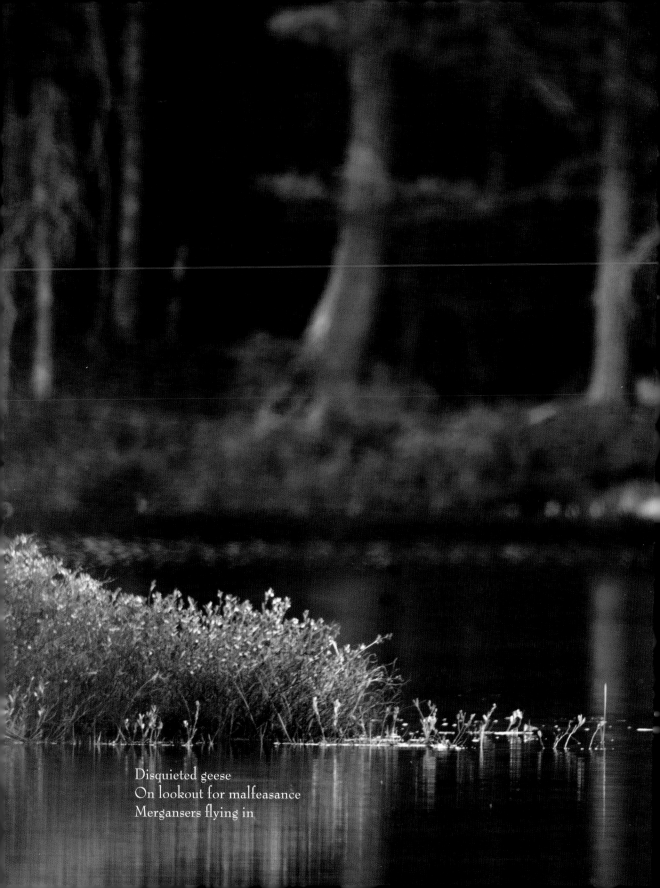

Disquieted geese
On lookout for malfeasance
Mergansers flying in

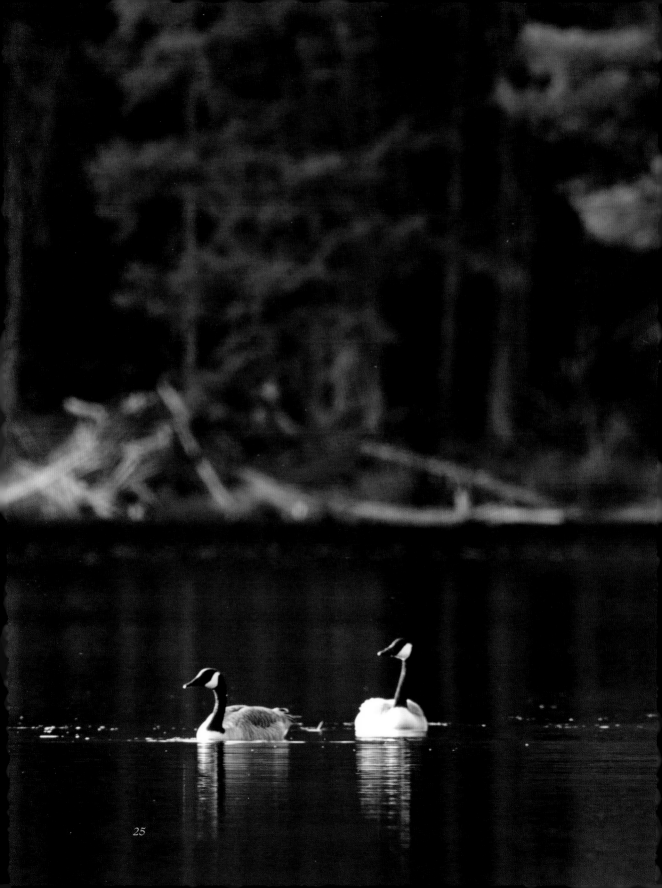

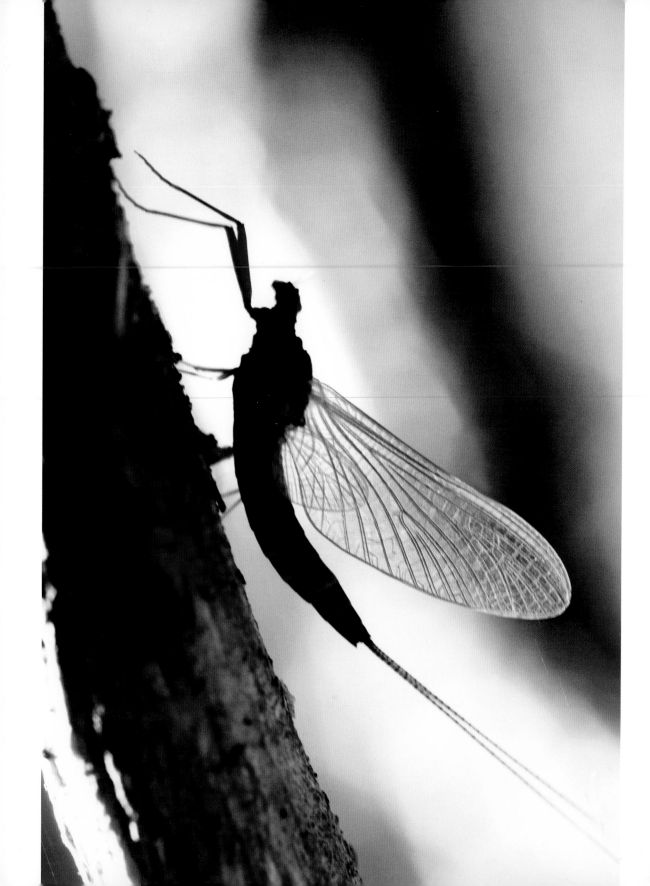

Hatch

The pond lies mirror-smooth on a warm afternoon.
A flock of mergansers drifts along the far shore
leaving thin, sunlit shimmers in its wake.
Dragonflies ride the air with helicopter wings
clashing at each turn, coupled in flights of ecstasy.
A cow moose feeds in the shallows
lifting her head to look, to listen
seemingly unaware of life unfolding below.

Year-old nymphs, the final edification of the mayfly molt
are stirring in the sedimental ooze, testing fledgling limbs
an arousal for their final stage, primordial, eons old
inspired perhaps by drooping cedars along the shore
whose roots tap-tap a wake-up call; it's time to go
upward from darkness to warm air, the light of day
to dry their wings still wet from a watery birth.

Like stars in the night sky, mayflies pepper the pond
turning the smooth surface to a glittering plain
soon to rise, to take flight on membrane wings
to fly through gathering flocks of predatory birds
swooping through the hatch with hungry beaks where
for a few precious moments, they copulate, fall to earth
begin again.

A young doe feeds slowly towards me as I stand motionless in the black growth.
Quick movement will scare her and she will be gone in a flash, so I am careful to
raise my telephoto lens with no more speed than that of a pine bough moving in a
gentle breeze. Still she senses my presence and lifts her head and stares directly at
me.

Reverence

Perhaps I cause a disturbance in the air
felt only by animals in the wild

or perhaps it is because of the odd symmetry of
my rounded lens amongst organically shaped trees.

She may even hear the rhythm of my breathing
or the beating of my heart.

And yet there is no sense of fear even as my shutter clicks, only curiosity as she
tilts her head one way then another. Satisfied that I pose no threat, she returns to
feeding and over the next few minutes moves on out of sight

leaving me with a sense of reverence
for having been in the presence of

one of nature's most beautiful beings
on her terms, not mine.

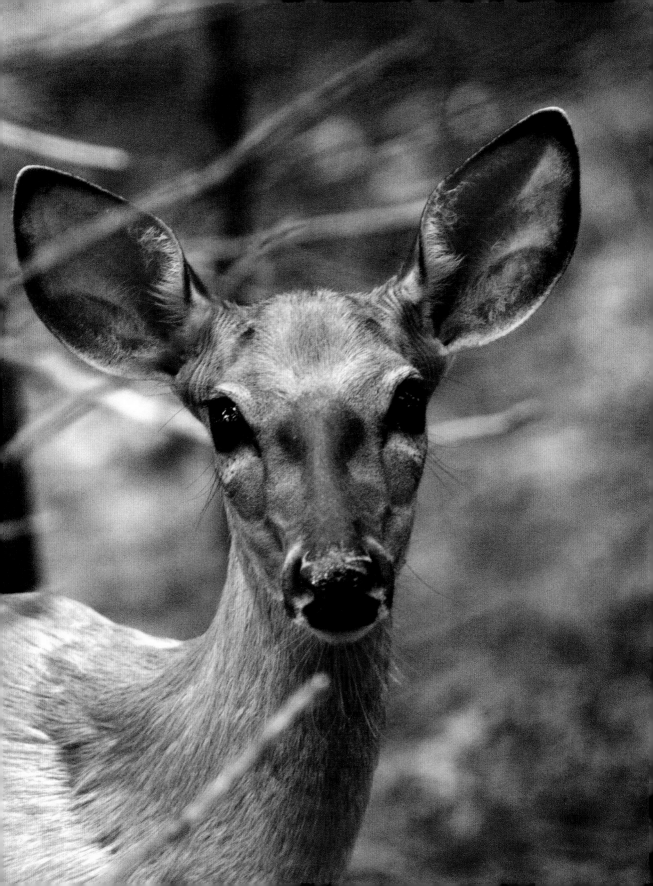

Journey

For a brief span-
fifty yards more or less-
the trail to my camp
is contiguous with the AT
as it skirts the edge of
Plant Pond where
I am concealed
on the far shore
with telephoto lens
waiting and watching
for the antlered moose
to reappear that
I had seen in years past
feeding on lily pad shoots
in the shallow cove.

Across the way
I watch hikers come and go
some in chattering groups
others traveling solo
but always at a pace
infused with destination
Katahdin to the north
Georgia to the south, or
for those less inclined
to notch their resumés
a more moderate egress
somewhere in between.

Part of me is envious
of those with legs of steel,
of the sheer perseverance
it takes to hike the trail, but
sitting here in silence
I cannot help but feel that
in their headlong rush
they miss the nuanced voice
of the surrounding woods
a voice that fades to whispers
at the approaching sound of
Vibram soles.

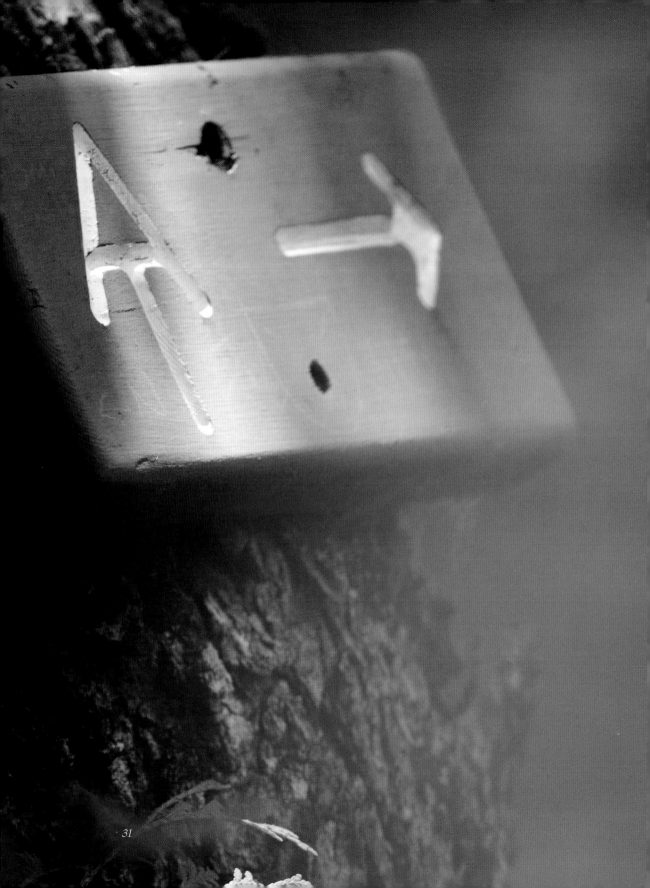

Chatter

A red squirrel scampers above
dancing nimbly limb to limb
sensing the man below, exclaiming in
neurotic chatter and flagging tail
a warning to all who would hear
followed by a hasty retreat.
Cacophony vanishes over the ridge.

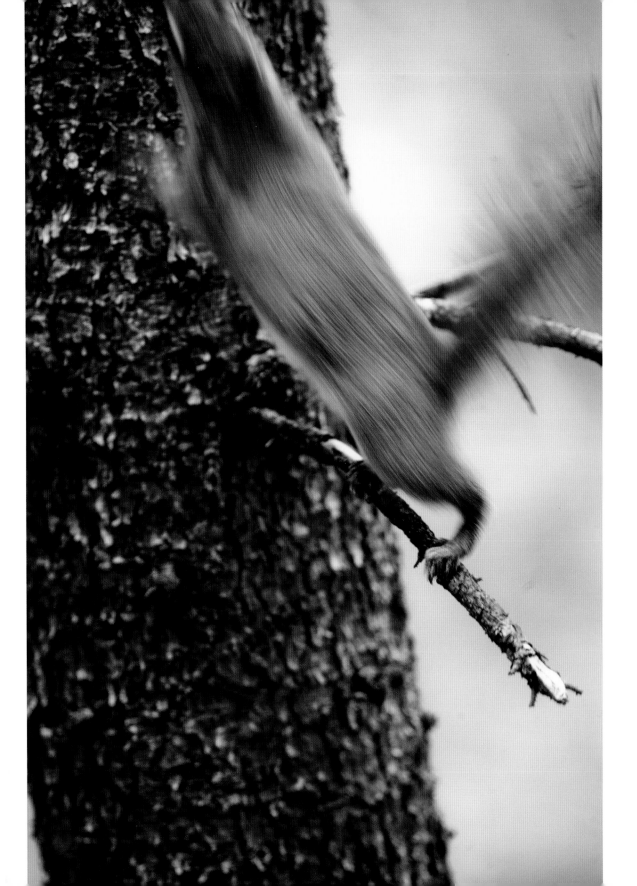

Listening to Beethoven

Beethoven's sixth playing on the porch
grandeur of horns and drums to delicate flute
the sounds and images of the surrounding woods
resonating in every note.

Across the pond on the northern ridge
an old-growth pine chimes in, top astir, wind on the way
a northwesterly, blowing in fits and starts
more a hammer to begin, a whisper by wind's end.

The rising breeze dives over the ridge, churning
the waters of the far cove into a spray of windswept light.
Cat pawing, reforming, it begins its march across the pond
creating a skirt of angry water laced with whitecaps.

The barrier trees, antlered and ragged from winter storms
stand defiantly on the windward shore, awaiting the rushing air-
Gurkhas on guard for tall, thin spires beyond - protecting them
absorbing nature's force so others may live.

Tempo changes, the wind recedes, fades
the pond now smooth, reflecting sky's blue, white clouds
horns, drums descend to clarinets, a lonely flute is playing
wind to a whisper. A tiny cone falls to earth

pianissimo, sotto voce.

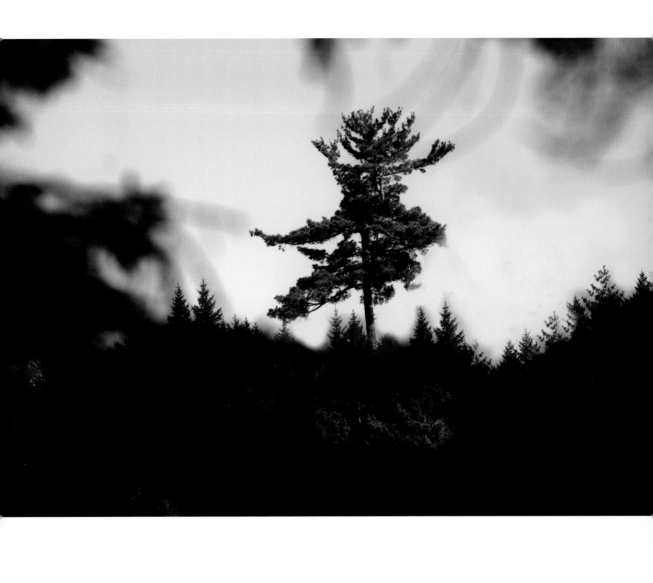

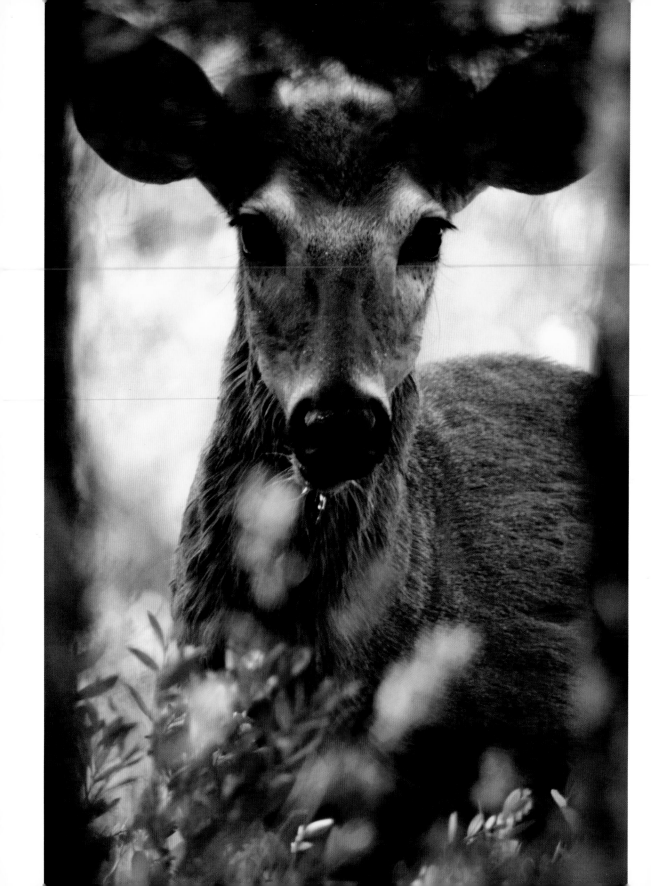

Hunter

The hunter in hiding, well-concealed
fragments of Cabela's green and gray
amongst spruce and fir - believing
he dispels the aura that follows
a man in the woods, a moment when
every living thing holds its breath.

The scene a sheltered cove
nature's nutritional store
feeding ground for does with fawns
for gangly, long-legged moose
and young bucks, yet unaware
of the dangers of open space.

The cove awash in morning light
each leaf and blade of grass backlit
effervescent and glowing brightly
enhancing the palette of early fall
green gone gold, russet and red
complementing pond's blue.

A strand of spider's web drifts
a spiral on the moving air
a thin shimmer, a splinter of sunlight
against black growth beyond
reminder of nature's slow turn
of the quiet rhythm of the woods.

Birds hidden in low-lying shrubs
add to the auditory pastiche as they
flutter from branch to branch
in search of late summer berries
residual morsels of sweetness
overlooked by foraging bears.

A rustling of fur on spruce.
The hunter's eyes peel, sharpen, as
a young buck emerges warily
from out the trees, and
with hesitant steps, slowly
picks his way to water's edge.

The deer's nose nods, nostrils flare
olfactory senses alert, testing the air.
Ears perk, twitching, as he listens
attuned to predatory stalking
a coyote lurking nearby or
worse still, more than one, a pack.

Sensing safety, lowering of guard
the deer begins to feed along the shore
yet unaware of the preying eyes, while
the hunter remains one with the woods
motionless, heart beating, anticipating
waiting to take his shot.

Nearing the trees, the young buck stops
millennia of survival genes on high, as
he listens and stares intently, quizzically
at the unfamiliar shape holding, what?
Reflecting glass eye, round, rainbow-hued?
Metallic click, a strange sound:

Image captured.

Partners in sky,
Usher in starry night as
Evening light slowly fades

The loon circles anxiously in the cove
waiting for the wind to rise on the tiny pond
to lift its body, heavy with the day's catch
above the treeline into the sky.

Airborne

Further west, a hesitant breeze gathers
squirreling around, spiral whirlpools in the air
tap dancing on the surface, slowly becoming
ripples, dark water, whitecaps.

Sensing the change, the loon turns, airplane-like
facing the oncoming wind, making its move, now
paddling hard; frenetic flapping wings
tinker drumbeats against the shore.

Paddle becomes a run, thrusting forward
footprints on the pond, spray in the air
skipping stone in reverse, as bird races on water, then
wind under wing, lifted, airborne.

Rising off the pond, moving fast
the loon closes on the far shore; a stand of
tall pines giving no quarter to this crazy bird
heading straight its way.

White belly bared, attitude in flight
the loon banks left, avoiding outstretched limbs
as it follows the contour of the pond
each wing stroke taking it higher still.

Veering east, it heads downwind, losing lift
pumping ever harder, wings grabbing air
its body a flash of white on dark growth, as
it rounds overhead, heading north.

Turning windward, a sudden gust
propels it upward over the trees, becoming
a dark, speeding shape against blue sky, celebrating
one last trip around the pond.

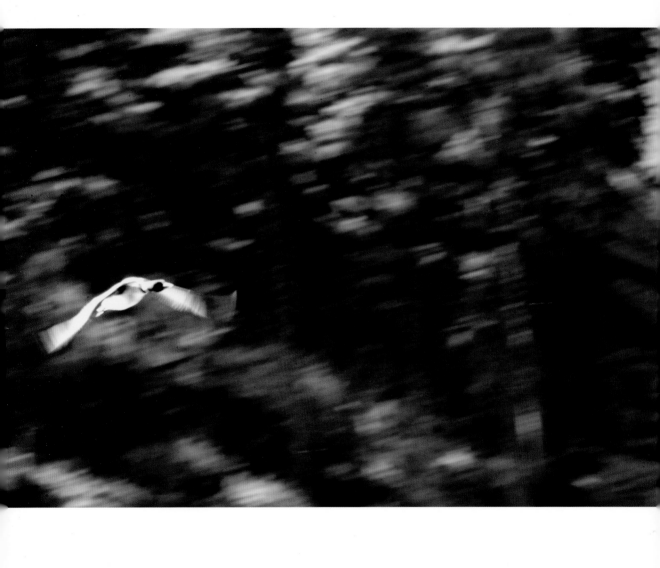

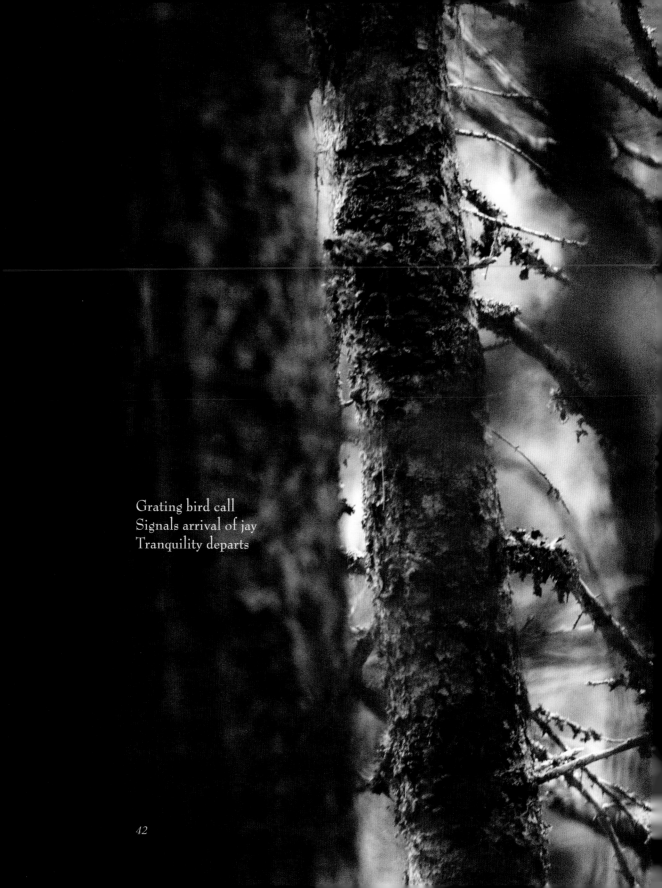

Grating bird call
Signals arrival of jay
Tranquility departs

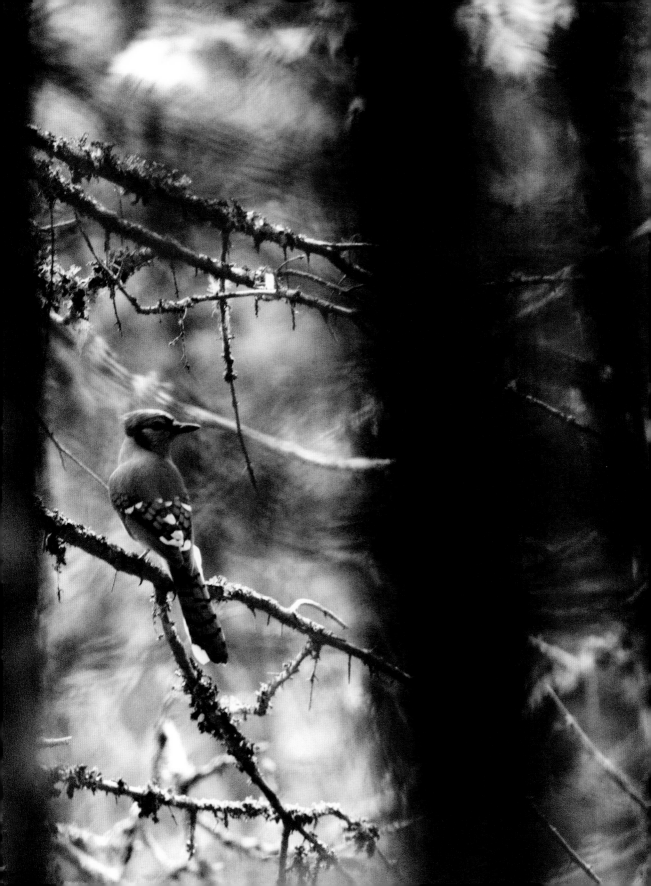

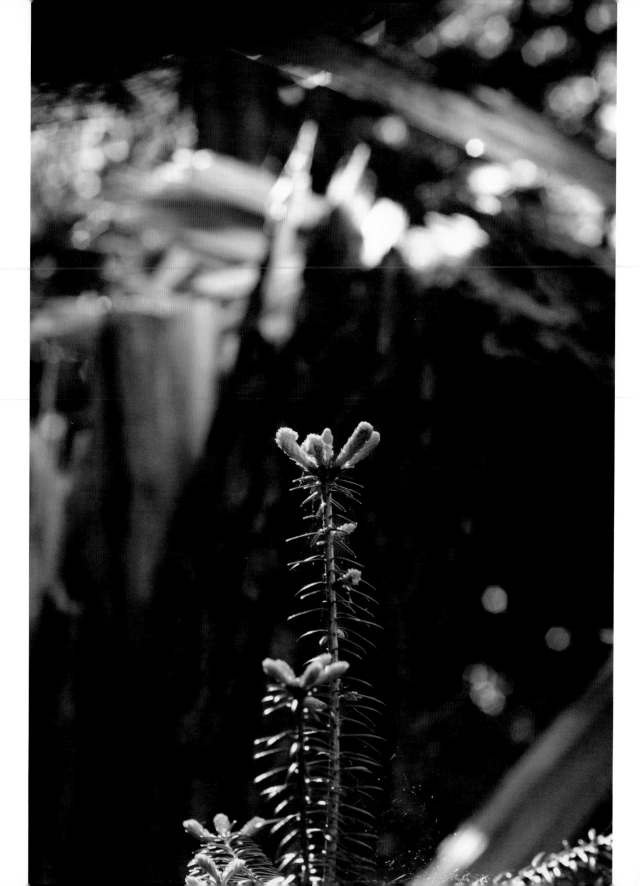

Solace

I imagine it was deathly cold that day when
the harsh wind from the pond joined forces
with the crackling northerly surging over the ridge
rattling icy beeches as it roared through the woods
leaving a path of devastation in its wake.

Jack firs channeled the wind stronger still
as it slammed the black growth, becoming
too much for the winter-brittle trees to bear
as they whipped violently in the gusts
straining to stay upright, to stay alive.

In the aftermath, the ridge was speckled with
the jagged teeth of freshly snapped trees
where they fell interlaced and pointing downwind
a chaos of coniferous trunks and branches in a
tangled carpet of mayhem and death.

Yet

though they lay dying, the fallen trees had built
a sheltered womb, a place where spore would thrive
to one day rise above the rot to color the forest green
with young spruce and fir, which, in nature's turn
would owe their strength to those who died that day.

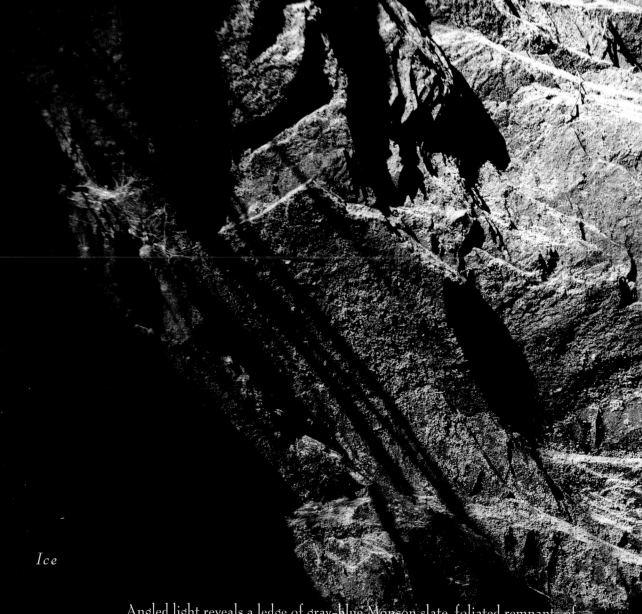

Ice

Angled light reveals a ledge of gray-blue Monson slate, foliated remnants of volcanic ash reformed eons ago. The ledge's silky-smooth crest rides a ragged southern flank, shattered by the weight of countless years of ice.

Deep down, beneath the scree on the lee-side ledge lies a layer of bone-dry dust, residue from a glacial signature scratched across the barren knoll, a reminder of violent times brought on by climate change when all living things fell to the shearing force from the north.

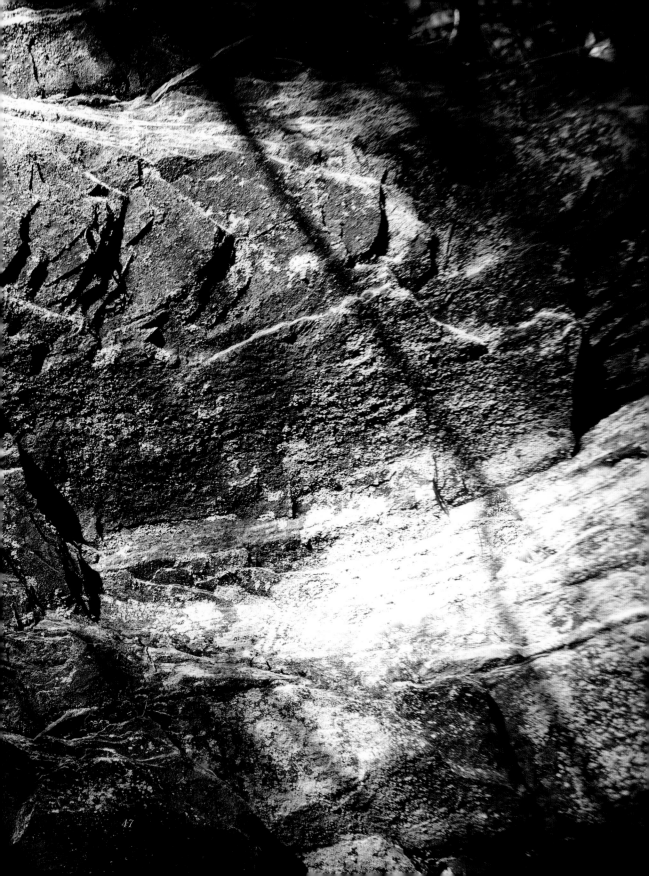

Transformation

Late afternoon sun
floods the cove near my camp
imparting an otherworldly glow
transforming aquatic plants into
silhouetted sandpipers
feeding on flickering light.

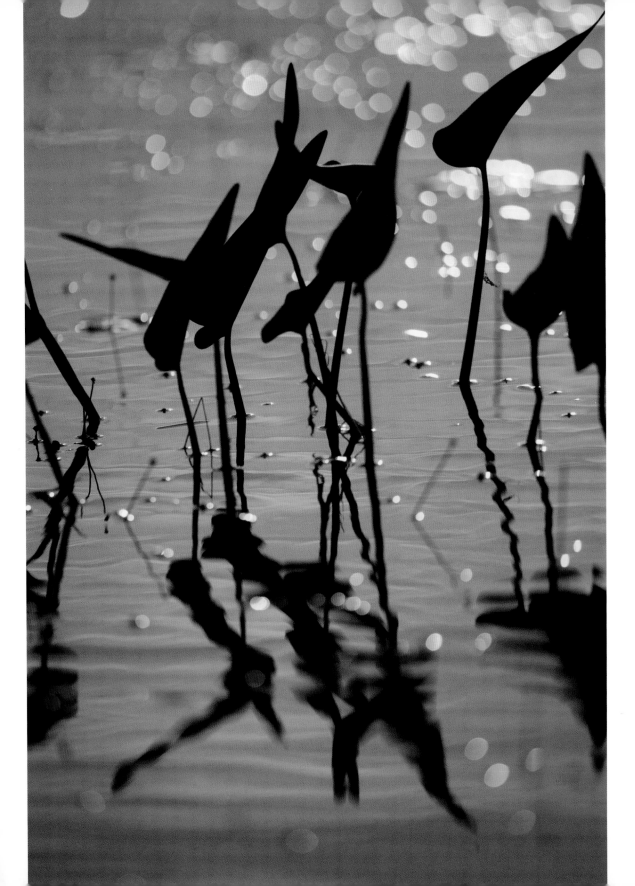

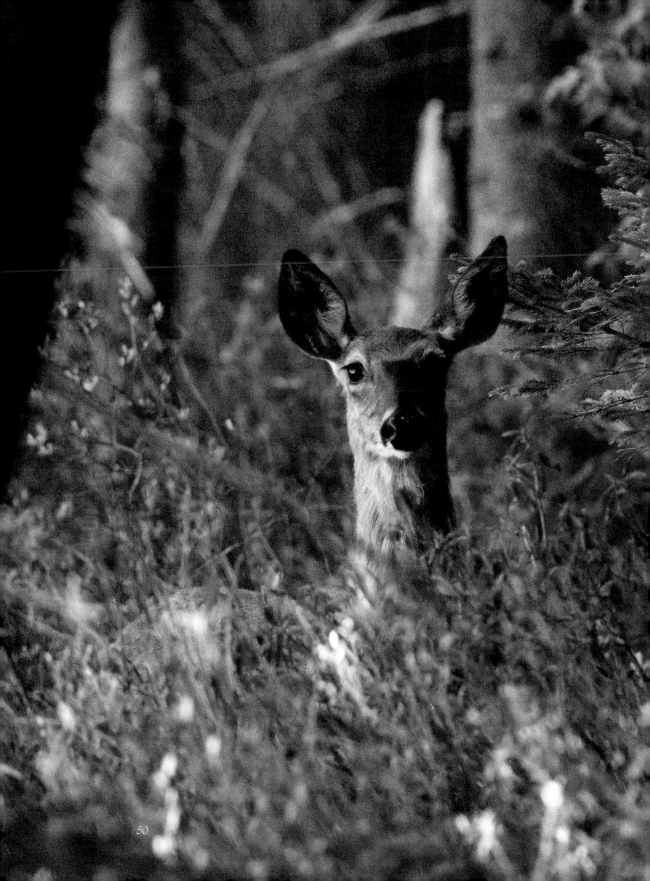

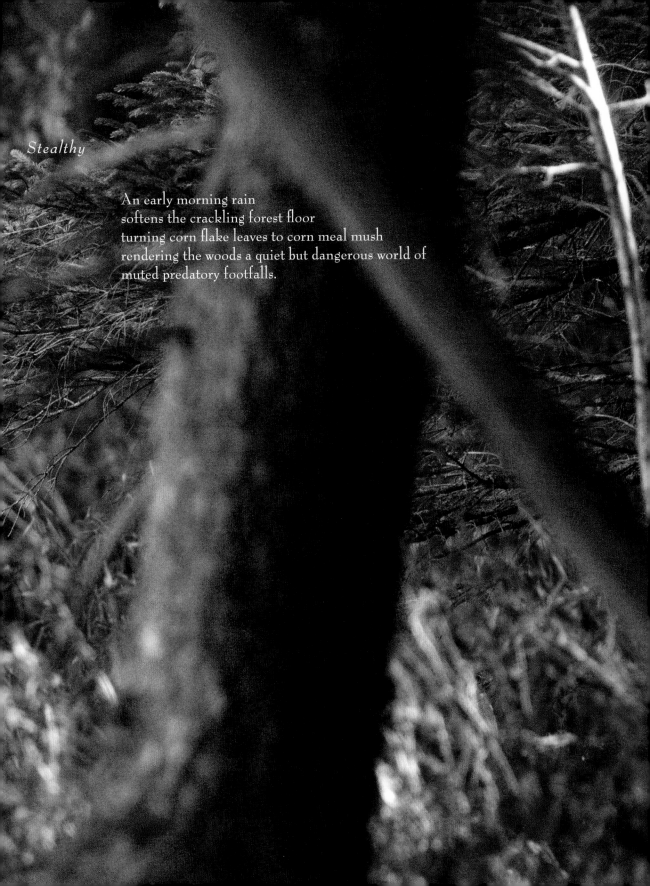

Stealthy

An early morning rain
softens the crackling forest floor
turning corn flake leaves to corn meal mush
rendering the woods a quiet but dangerous world of
muted predatory footfalls.

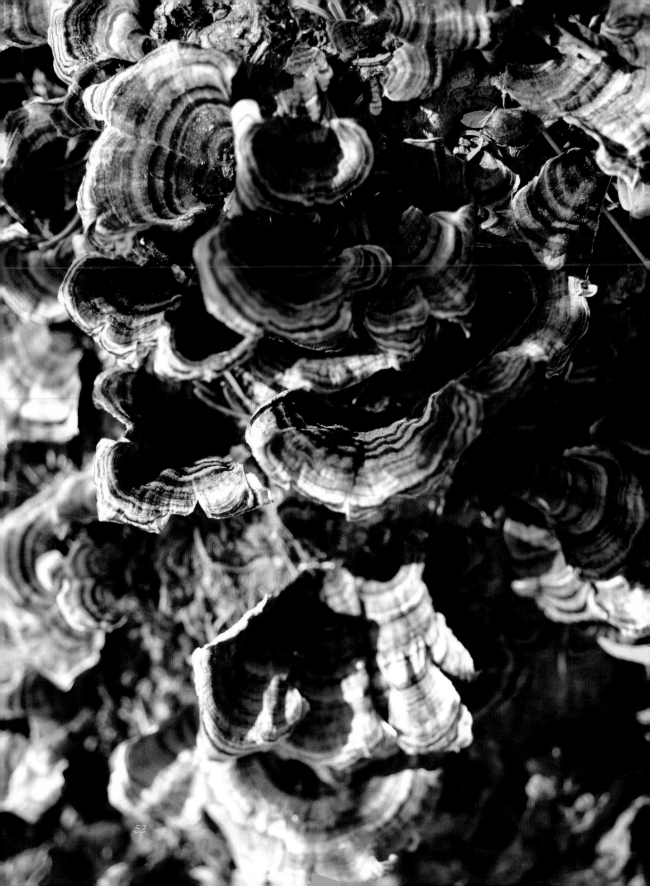

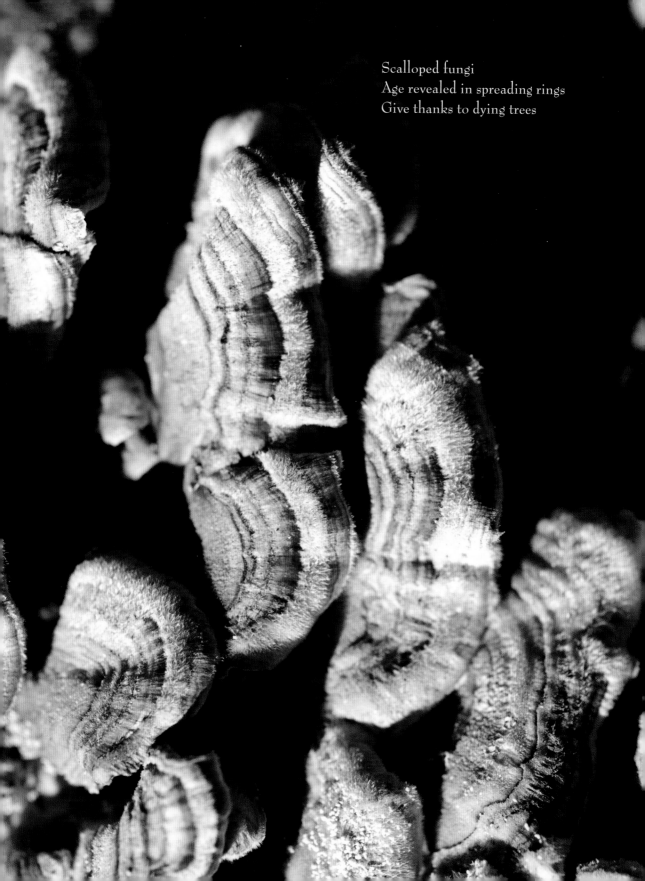

Scalloped fungi
Age revealed in spreading rings
Give thanks to dying trees

Living

Each year on my way to camp I pass by a young maple tree that struggles to survive years after a beaver had gnawed it nearly to its heartwood. I imagine trees too have their stories to tell:

Unable to move, I endure
sharp teeth, a beaver gnawing
cutting deep, hungry for lofty shoots
each bite, my life slipping away.

Midway, the beaver departs
leaving his work undone
a change of mind perhaps, or simply
repelled by maple-flavored wood.

Now alone, bereft
an apron of flesh around my trunk
I beseech my roots below
"Give me strength, I want to live."

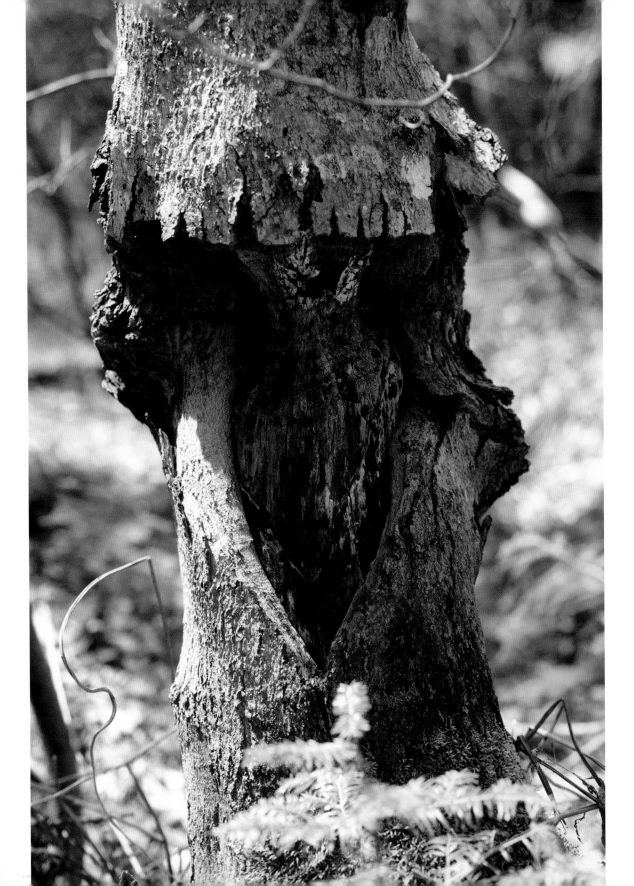

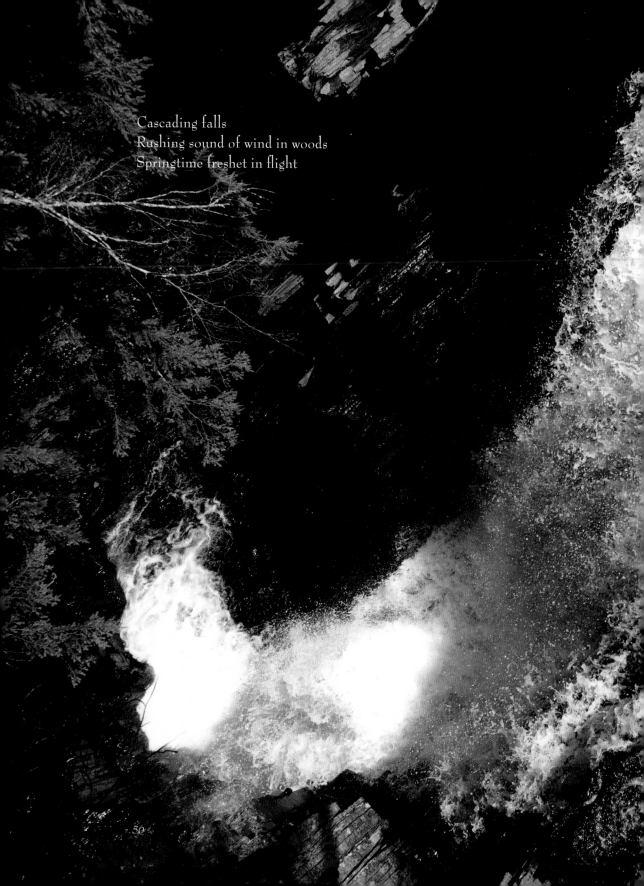

Cascading falls
Rushing sound of wind in woods
Springtime freshet in flight

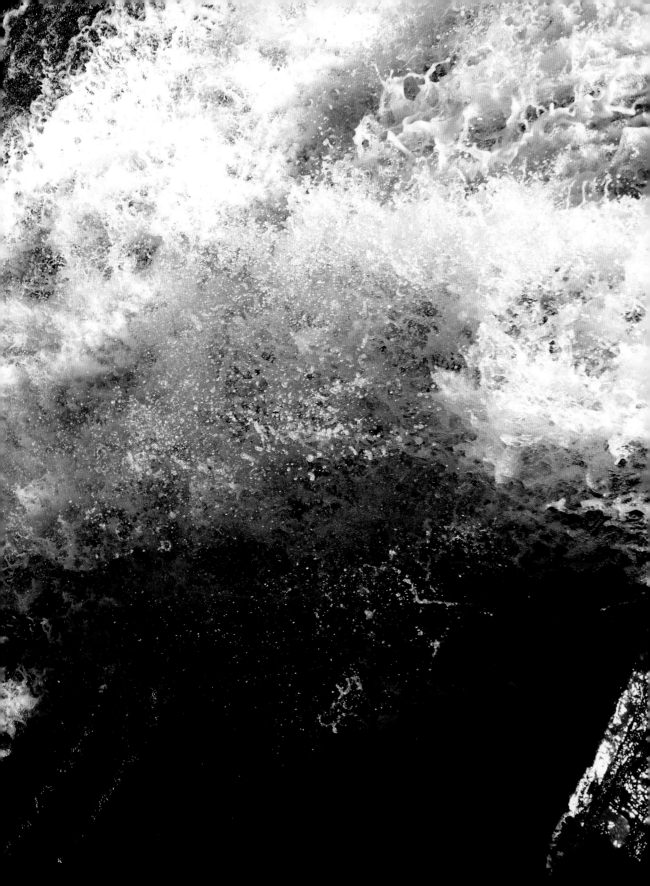

Reflections

Just above the falls
the stream begins to slow
as if to catch its breath
before the downward plunge
creating a quiet space where
nature knits and purls a
mix of earthy hues:
a flowing quilt of
moss-covered rocks
made brown by swampy tea
interlaced with blue sky and
drifting clouds, where
jagged lines of spruce and fir
entwine them all as one.

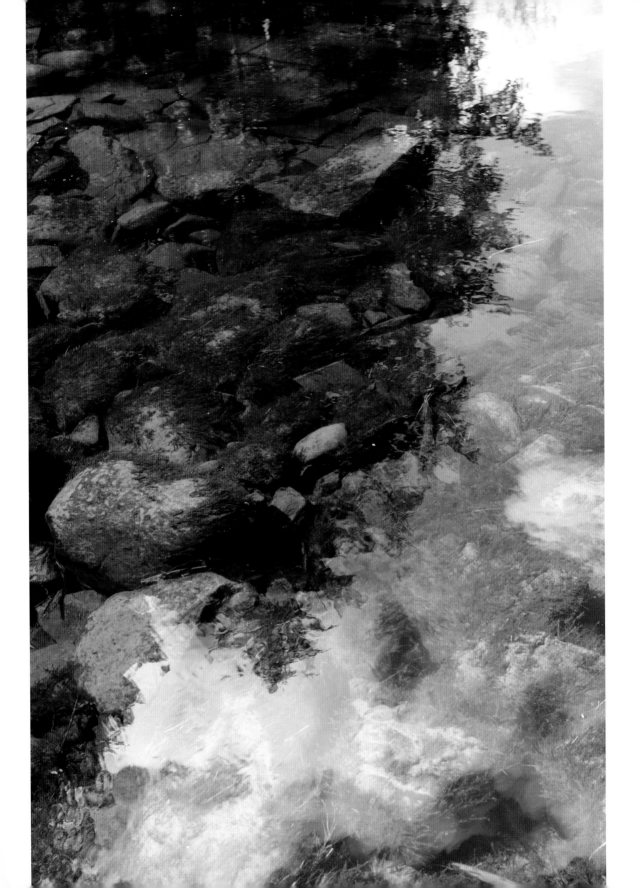

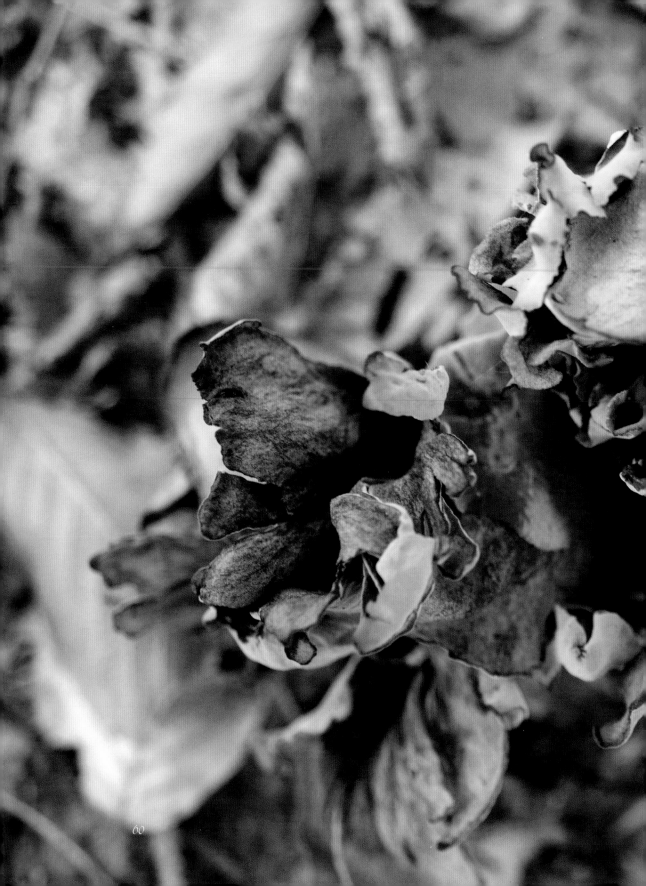

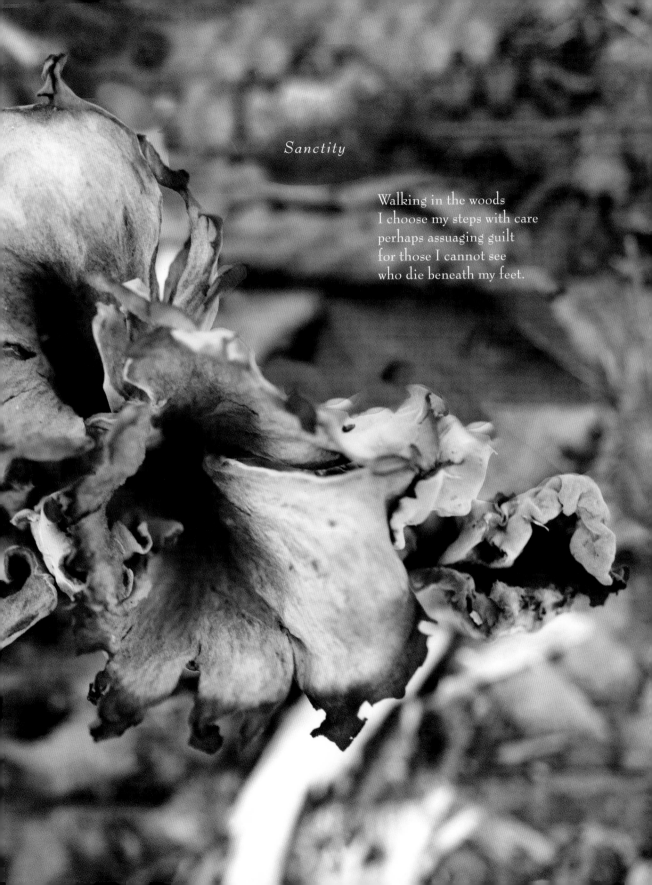

Sanctity

Walking in the woods
I choose my steps with care
perhaps assuaging guilt
for those I cannot see
who die beneath my feet.

Loon in repose
Periodically dips
Chance of meal looking up

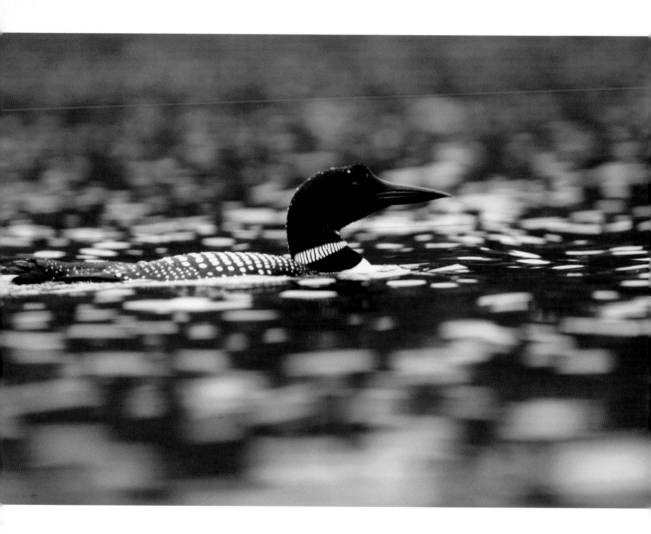

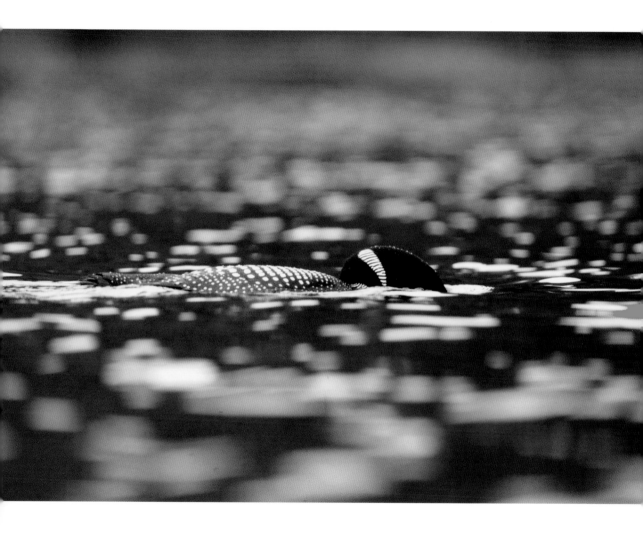

Renewal

Years ago, loggers felled an old-growth pine on the mossy knoll near my camp. Today the stump can still be seen, weather-beaten and getting on in years, its enormous girth the only reminder of the great tree it had once been. Tiny spruce and fir have taken root in the punky old stump, tapping into its nutritional stores, a touch of Miracle Grow for saplings beginning life anew.

Whenever I pass by I take time to pause as though in an existential place, to bear witness to the cycle of life, death and renewal within this tiny space, to see events through nature's evolving prism of everlasting life, where trees live their lives, drop their seed, grow old and die amongst their offspring, and over time provide sustenance for future generations to carry on.

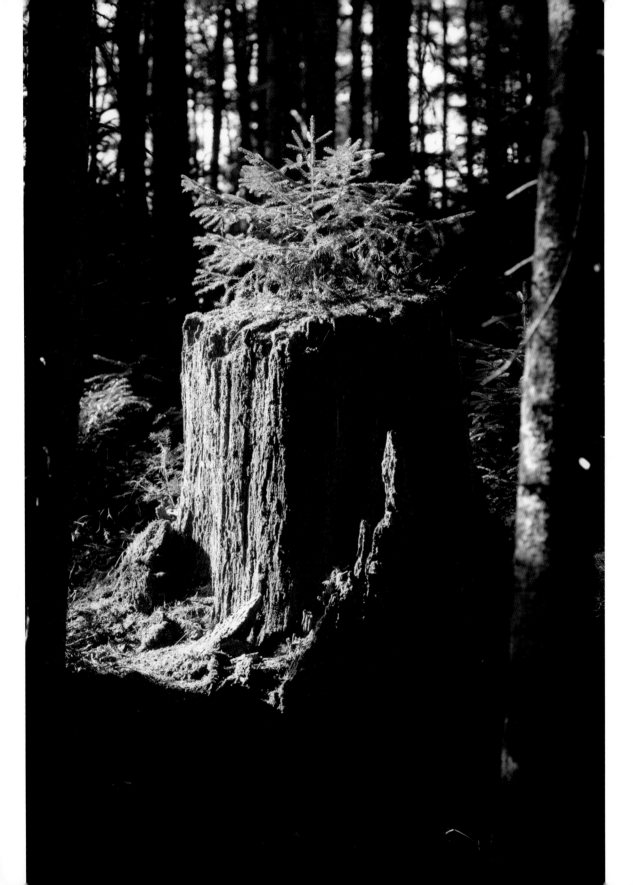

Silence

A dripping woods
devoid of boreal sounds
of the piercing calls of jays
of thrush from far away.

Absent are the quiet sounds
the hum of insects in the air
the tiny clicks and clacks
of nature's flock

save the mournful call
of a bull frog, its harrumph
echoing across the pond
calling back the rain.

Woodpeckers

The muffled, tapping sound of a woodpecker draws me to a tall spruce tree near my camp. Why the strange sound, I wonder? Instead of the woodpecker vigorously drumming on the outside for food, this Black-backed Woodpecker is inside the tree building a nest.

Beak appears bristling with
fresh cut splinters, wet with sap
thrown outward with a flip
spruce snow in the air.

As I brush wood flakes from my eyes, the male arrives full of aviary testosterone. Nest building on hold.

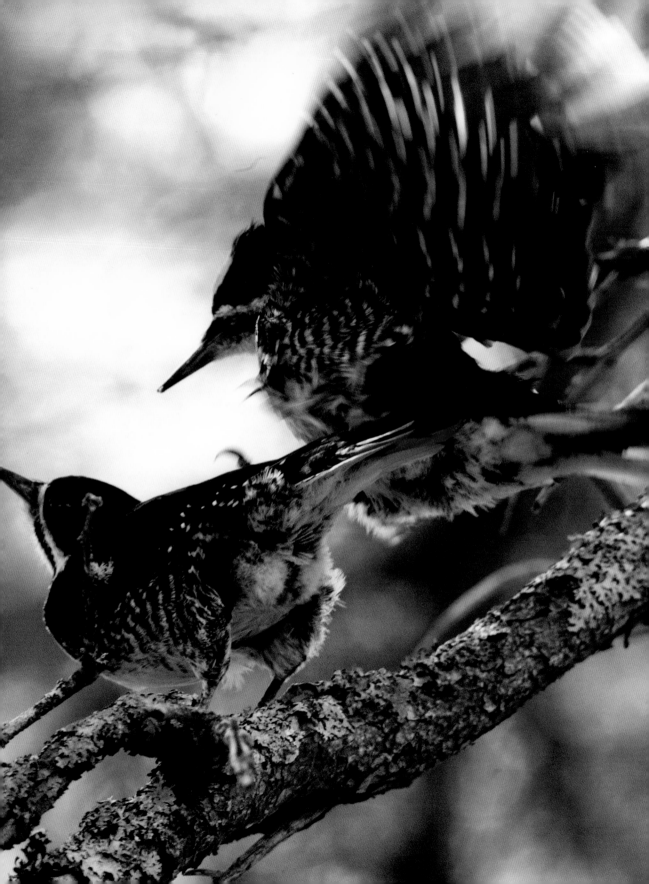

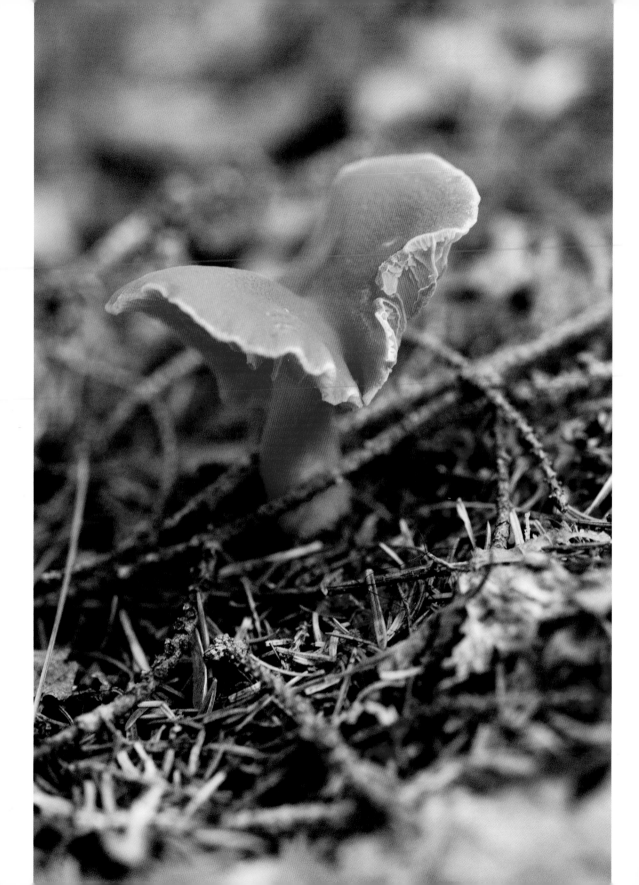

Vincent

With spring's color gone, when
sap green turns to olive drab
the woods of early fall submits to
subtle hues, like Flemish art
before the trip to Arles,

save the lowly mushroom
organic impressionism splashed
at random on the forest floor
reds, yellows, pinks and blues
Vincent's palette in full bloom.

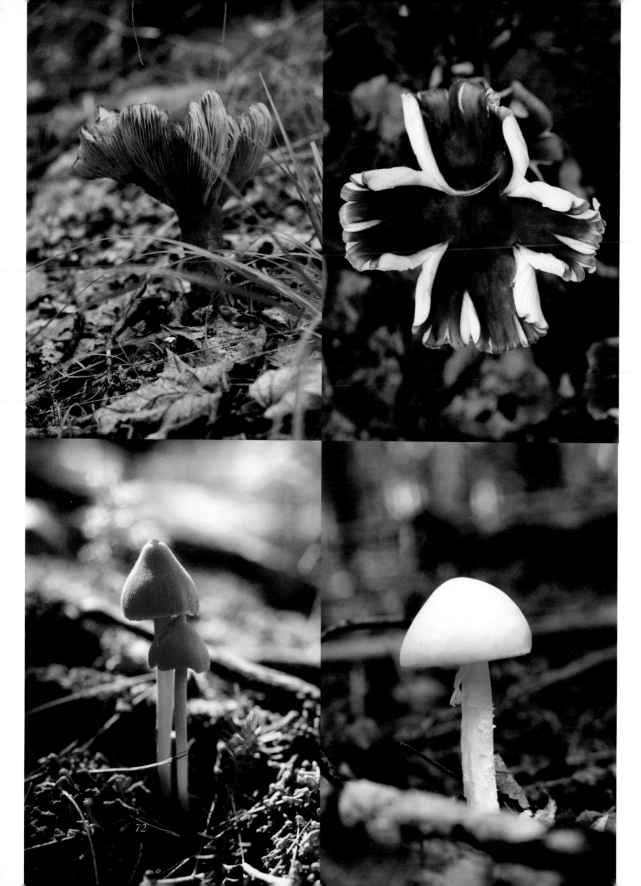

72

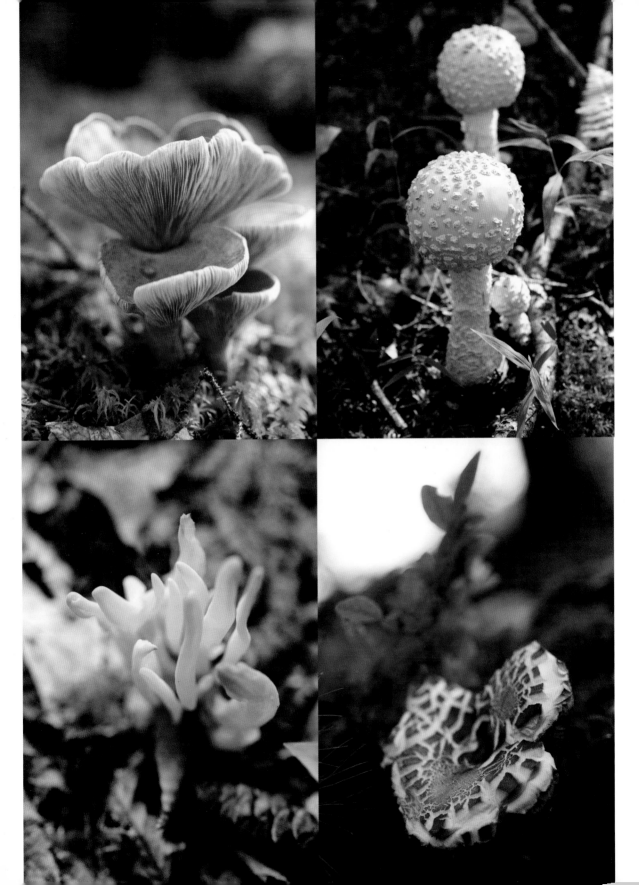

Dragonflies lived on earth millions of years before birds arrived and dinosaurs came and went. A dragonfly can speed along at thirty-eight miles an hour and fly eighty-five miles in one day, although they do so up, down and sideways in a very small space. And a dragonfly can see nearly three-hundred-sixty degrees, which is probably why they have been around so long. As Yoda would say, hard to sneak up on are they.

Jewel

They have perhaps the most delicious names in all the natural world, such as Skimming Bluet, Wandering Glider, Saffron-Winged Meadow-lark, Spangled Skimmer.

And their personalities are uniquely different: the Lance-Tipped Darner changes from naiad to adult at night, while other dragonflies undergo metamorphosis in daytime. A Lillypad Forktail prefers bea-ver ponds and bogs. A Dusky Dancer eschews vegetation and benignly perches on rocks, whereas a Pygmy Snaketail looks for exuviae on those same rocks. Sweetflag Spreadwing is heavily pruinose, while Frosted Whiteface has a bit of pruinosity on its thorax, and of course Calico Pennant looks like a Calico cat.

My favorite is the Ebony Jewelwing, especially when it flocks in a communal mating dance in the cool confines of a shadowed streambed. Like speeding electrons, two mating Jewelwings will dart in a tight circle so fast they appear as interwoven streaks trailing tails of luminescent blue in the cloistered darkness.

Exhausted from its love dance, a Jewelwing alights on a leaf where I view it close up as, in turn, it watches me with its three-hundred-sixty degree eyes.

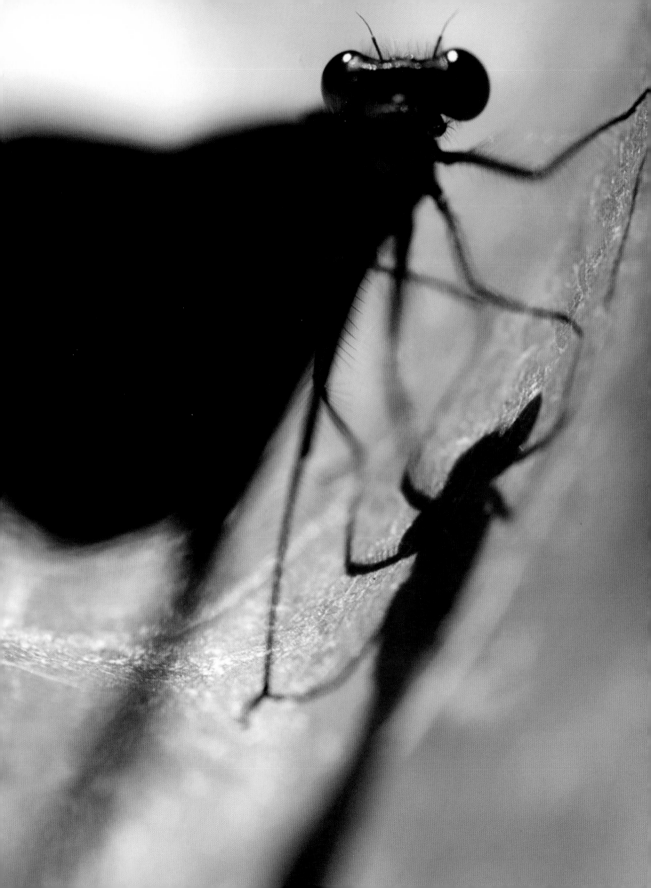

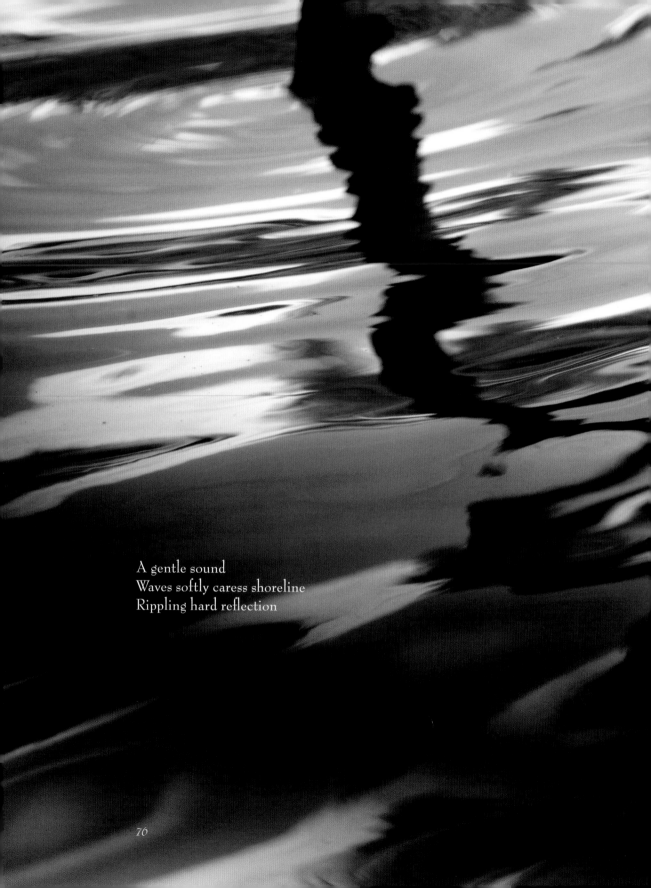

A gentle sound
Waves softly caress shoreline
Rippling hard reflection

76

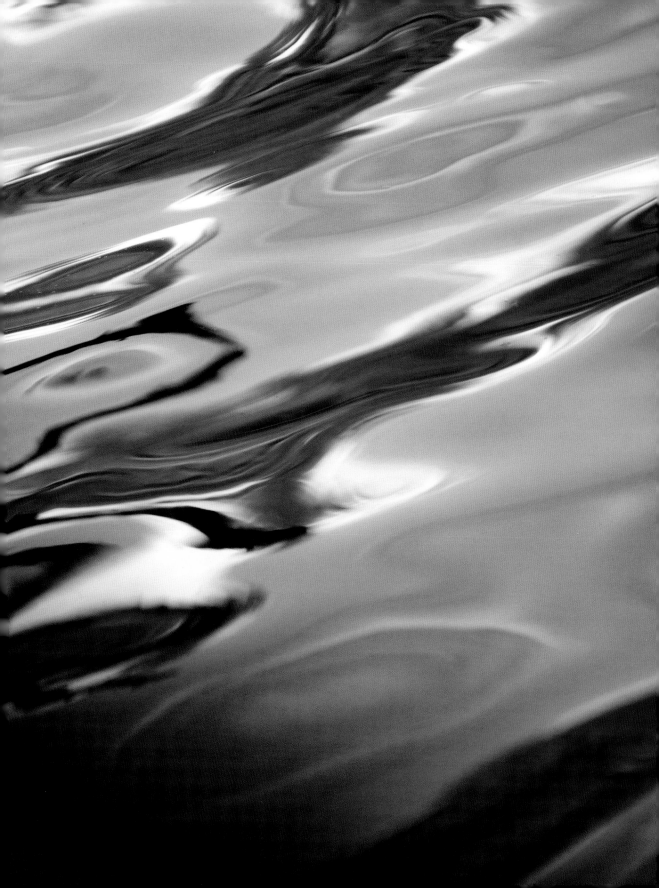

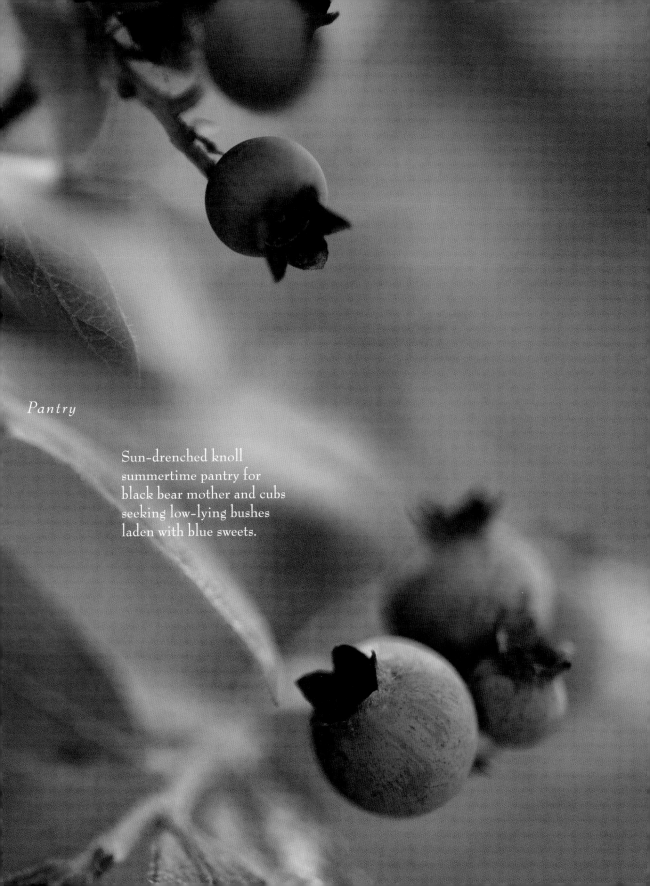

Pantry

Sun-drenched knoll
summertime pantry for
black bear mother and cubs
seeking low-lying bushes
laden with blue sweets.

Flint

Streambeds near my camp lay bare erratic stones, glacial detritus from eons of bull-dozing ice from the north. Sedimentary and igneous alike, these stones are irregular shapes, foreign to a country of stratified slate, each with its own pedigree, with travel-ing stories they and they alone could tell if only they had a voice.

One that does speak to me is Kineo flint, a rock from an outcropping a mere stone's throw away in glacial terms. Seen from the side, Mt. Kineo has a gradually-rising northern slope, a signature of glacial advance, leaving the mountain's southern flank a shear face with jagged boulders skirting its base.

For centuries Mt. Kineo was a source of flint for Native Americans which they crafted into weapons and tools. Chips of this hard but brittle stone can still be found scattered around ancient Indian campsites that often make themselves known when-ever the water level in a Maine lake is rendered low.

As a young man I walked those exposed shores and more than once held a flint ar-rowhead or tool in my hands, its top bleached white by ultra-violet rays, its unexposed bottom bluish gray, the color of Kineo flint.

Much of my youth was spent this way
roaming shores with downcast eyes
in search of white tops, hidden blue.
Little wonder I love this stone.

The Kineo outcrop is small, as geological formations go, barely a mile long and a half-mile wide. As a consequence, the glacial swath over which its boulders were strewn is relatively thin, and by some marvelous turn of fate, it passed directly over the ledge on which my camp is built.

To wit, a large flint boulder came to rest centuries ago on top of the ledge, as if it somehow knew that one day one of its kindred souls would show up and put down roots on that very same ledge.

It speaks to me and I to it as often in the evening
I place my hand on its weather-worn back
and say, "Old friend."

Among Cedars

My fingers run
through cedar sprouts
on velvet bark of older trees
and bleached, white bones
of those long gone

a place where

eager roots, rubbed bare
embrace the aging stumps
absorbing precious gifts
rich with nutrients
food from which to grow.

Were I to die today
my body to feed these trees
perhaps in future years
a traveler such as I
might pass this way

with searching hands
touching soft bark and
ancestral bones he might
sense my presence here
among these cedar trees.

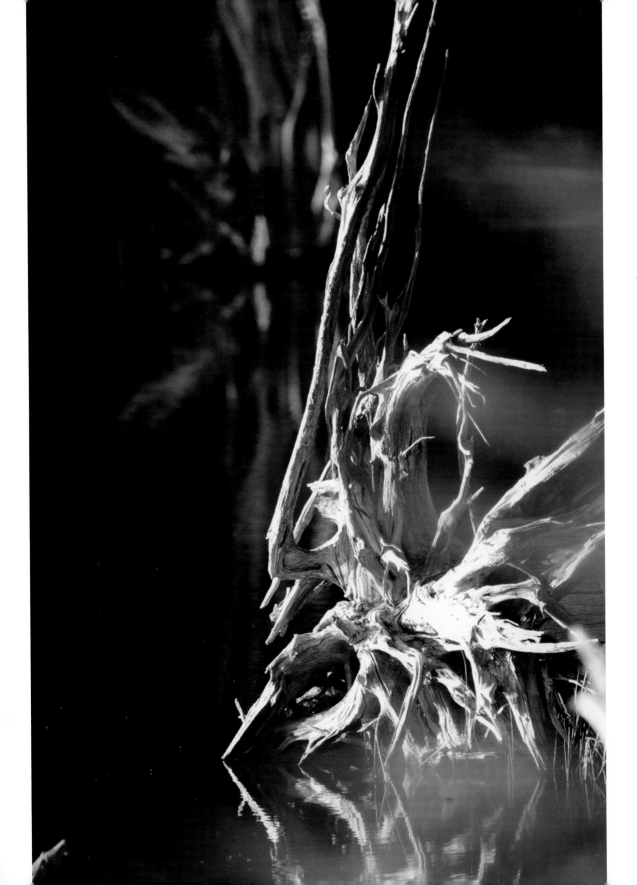

Starlight in pond
Mirrors universe above
Floating heaven on earth

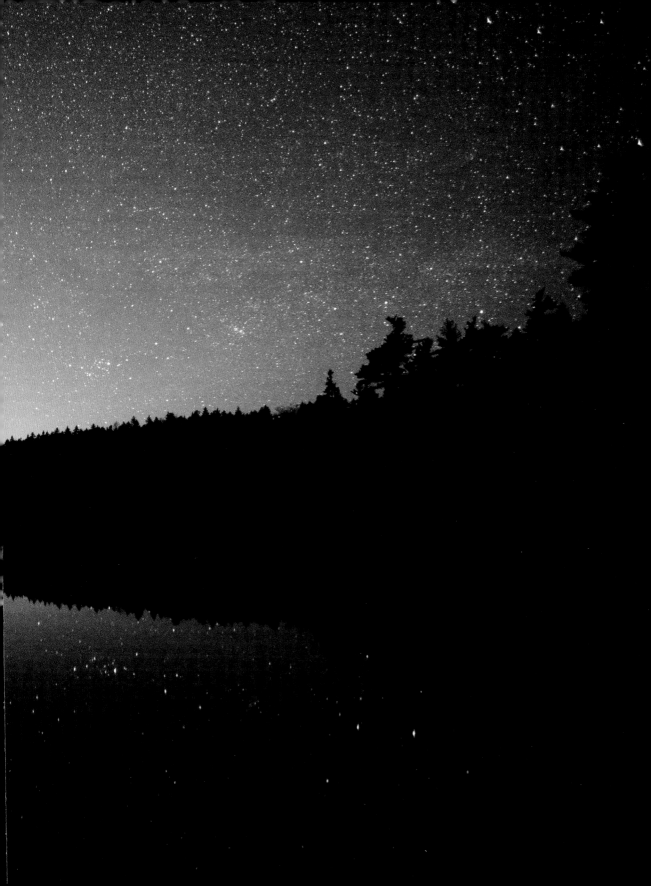

Each day at noon
a contrail arcs high over the pond
traveling from east to west
crispy white against sky blue.

Cathedral I imagine mellow passengers
with vivid memories of
anisette on the Left Bank, of viewing
old masters in the Louvre, of

reverential walks through
Chartres and Notre Dame
ornate cathedrals, testimonials to
man's quest for everlasting life.

Yet

I have stood in those holy shrines
with their towering man-made spires and
felt only the sweat of weary men
doing the bidding of men of God.

No such work among these wooded spires
whose reach is toward a giving sun
where existential answers are all about
for those who take the time to see

that we are one with the natural world
that God is in the woodwork telling us
that the spark of life among these trees is
no less great than that of man.

I have these thoughts

as my fingers caress a tiny cone
its seeds long spent to the wind
watching the contrail slowly fade to blue
water vapor, once warm now cool.

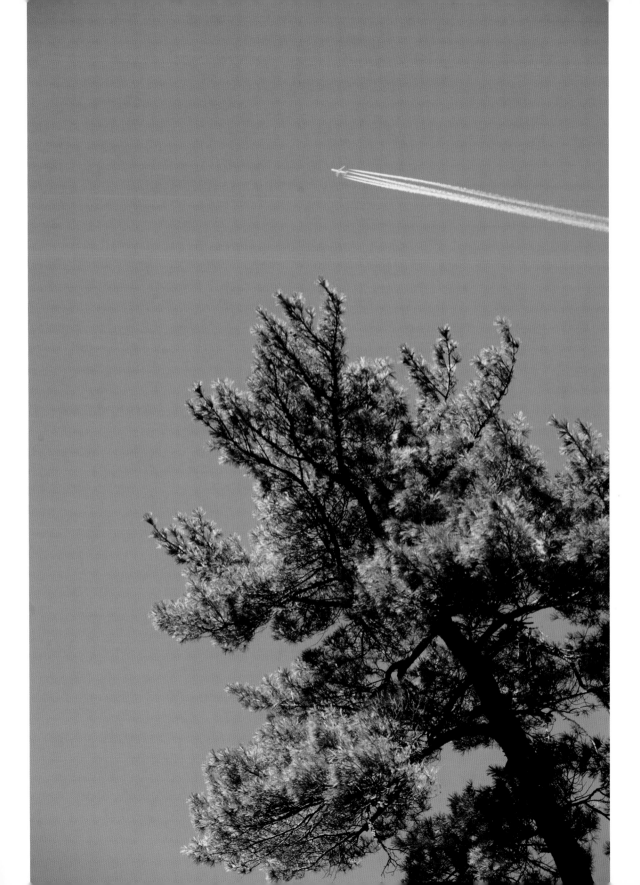

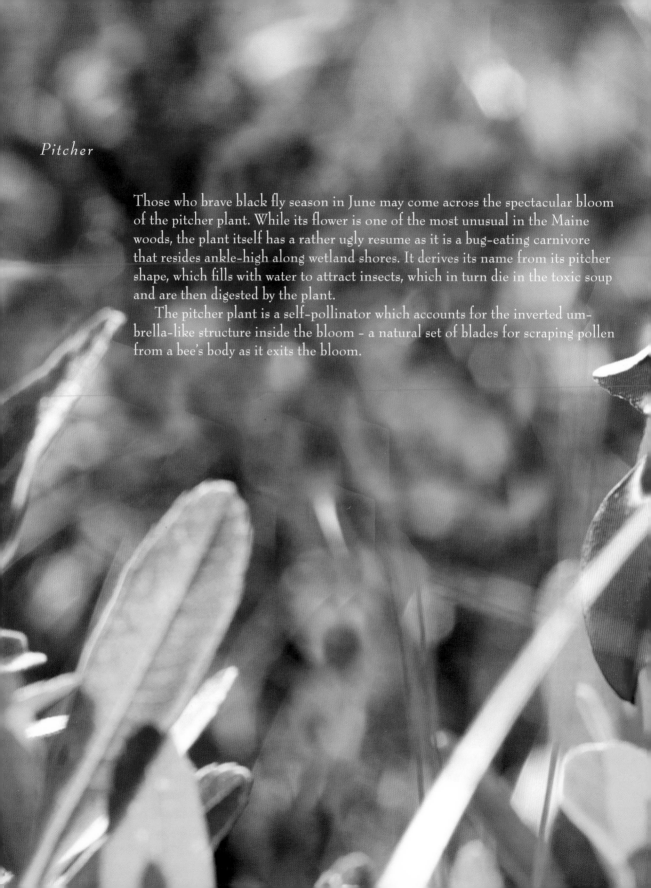

Pitcher

Those who brave black fly season in June may come across the spectacular bloom of the pitcher plant. While its flower is one of the most unusual in the Maine woods, the plant itself has a rather ugly resume as it is a bug-eating carnivore that resides ankle-high along wetland shores. It derives its name from its pitcher shape, which fills with water to attract insects, which in turn die in the toxic soup and are then digested by the plant.

The pitcher plant is a self-pollinator which accounts for the inverted umbrella-like structure inside the bloom - a natural set of blades for scraping pollen from a bee's body as it exits the bloom.

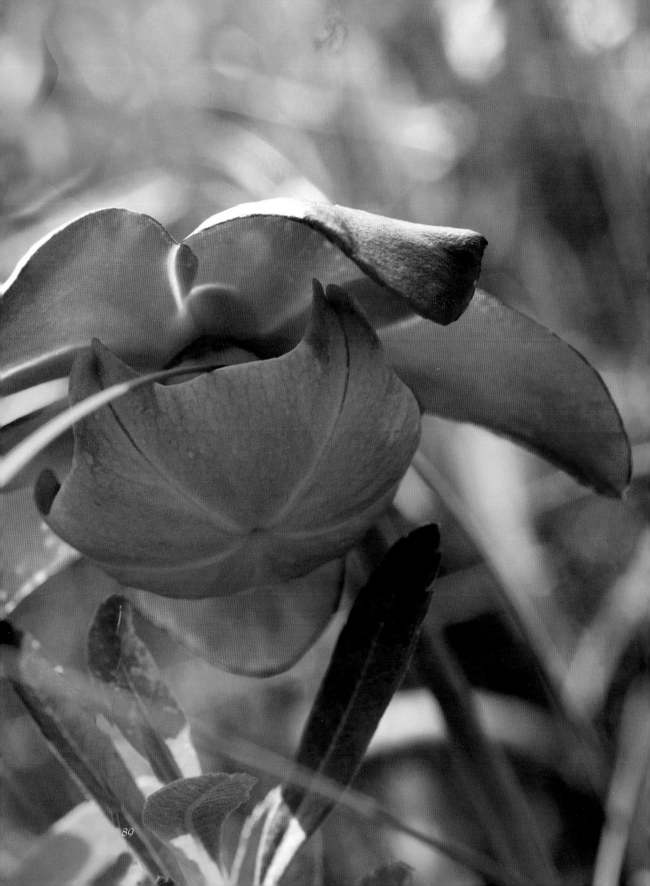

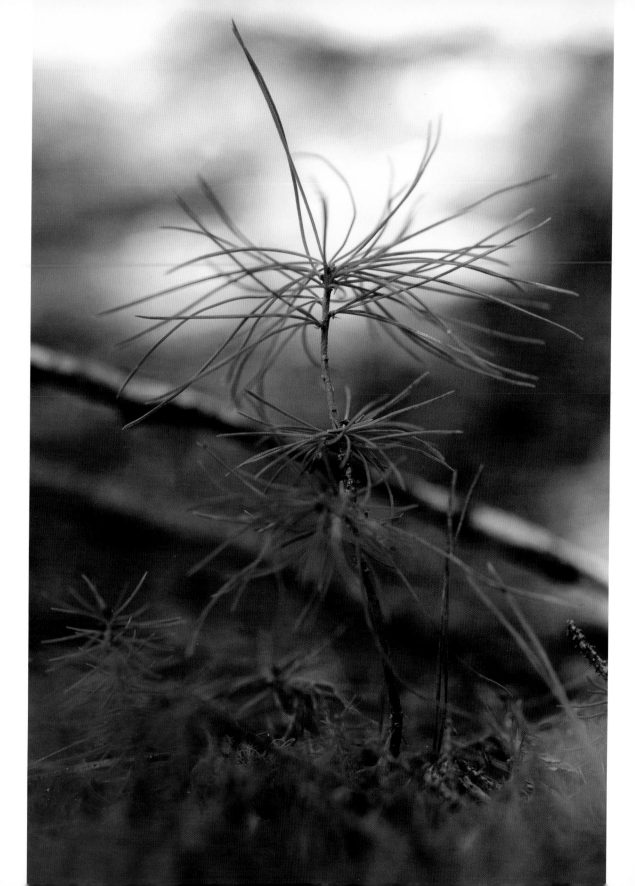

Clearing

As a young man

whenever I cleared a trail
cutting young trees, ending life
I found myself choosing
who would live, who would die.
Never an easy choice.

The first to go were
scrawny spruce, sharp needles
porcupine of trees
repellent to human touch
no mercy there.

Balsam firs were next
friendly spines, feeling soft
dark above, light below
fragrant-smelling pillows
Christmas tree memories.

Pines were the last to go
progeny of majestic trees
sentinels of the woods
towering high upon the ridge
symbol of the state.

Then one day

I heard a voice implore,
"Learn to walk around," it said
"let them grow, to live.
Next time you walk this trail
leave the axe behind."

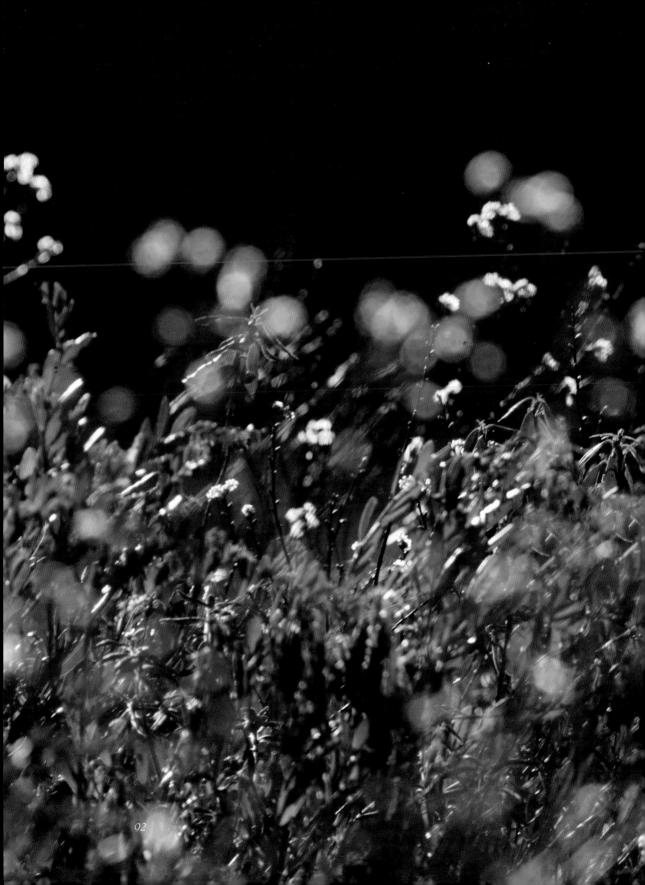

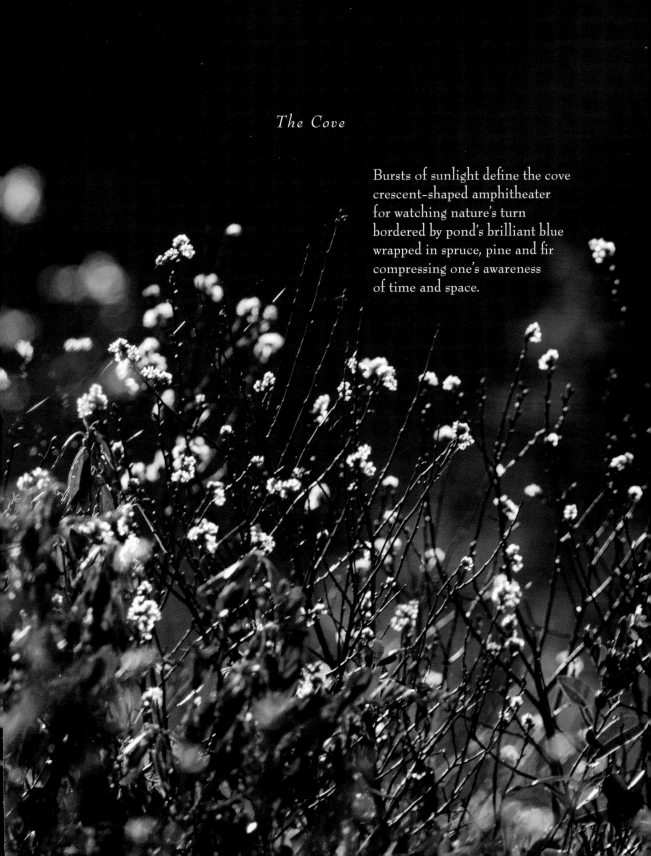

The Cove

Bursts of sunlight define the cove
crescent-shaped amphitheater
for watching nature's turn
bordered by pond's brilliant blue
wrapped in spruce, pine and fir
compressing one's awareness
of time and space.

Camouflage

A rustling of dry leaves reveals
a partridge hiding in the underbrush
camouflaged by shades of brown
no less obscure than those which
color its variegated plumage
bistre, ecru and fallow
mixed with a dappling of sinopia
and frosted with sienna over
the tiniest sprinkling of chamoisse
arranged around a fulvous neckline
set off by just a hint of isabelline.

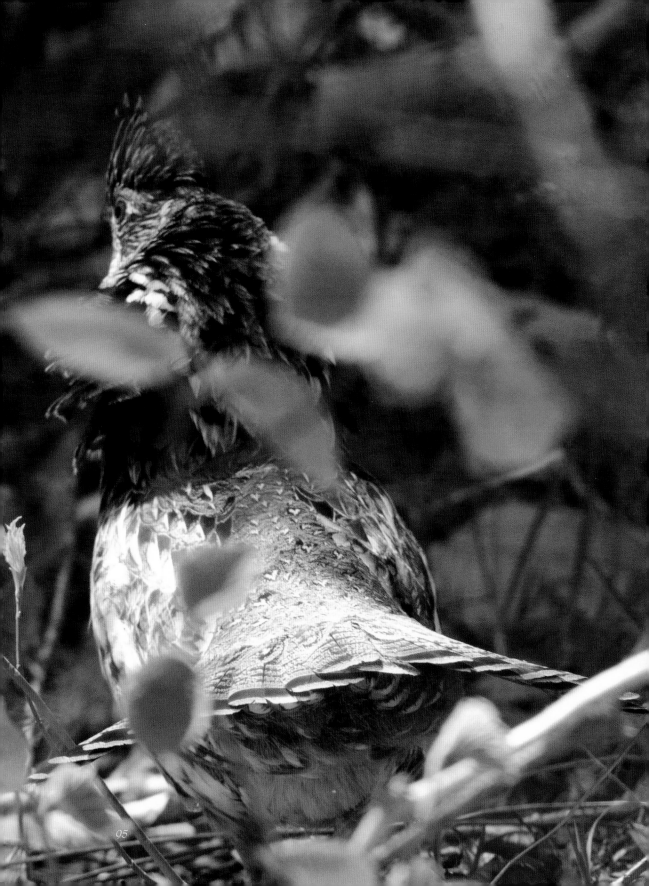

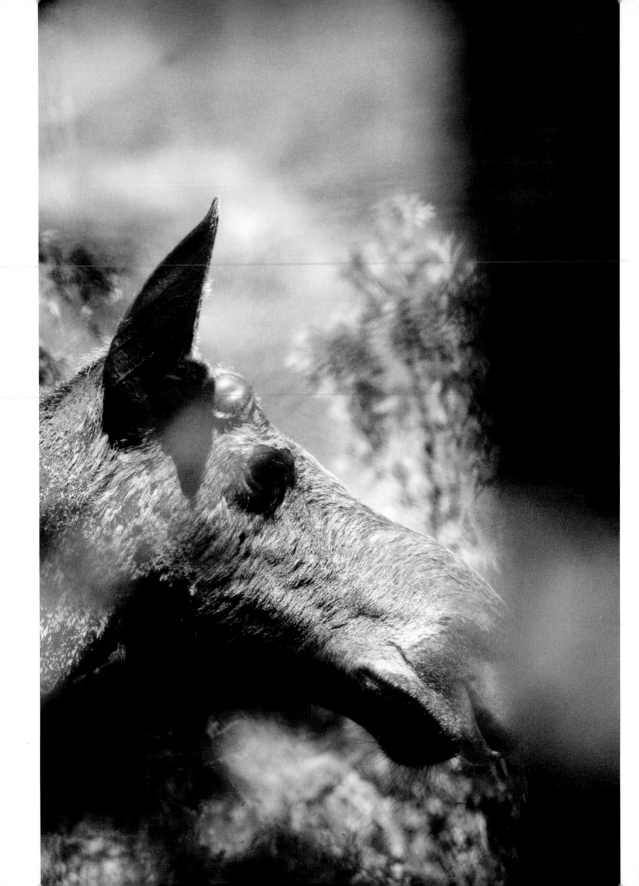

Seeing

Hush of boughs brushed aside
dark movement near pond's edge.

Head turns, looks

between trees, through lacy branches
into bright sunlight, darkened shade.

What is that?

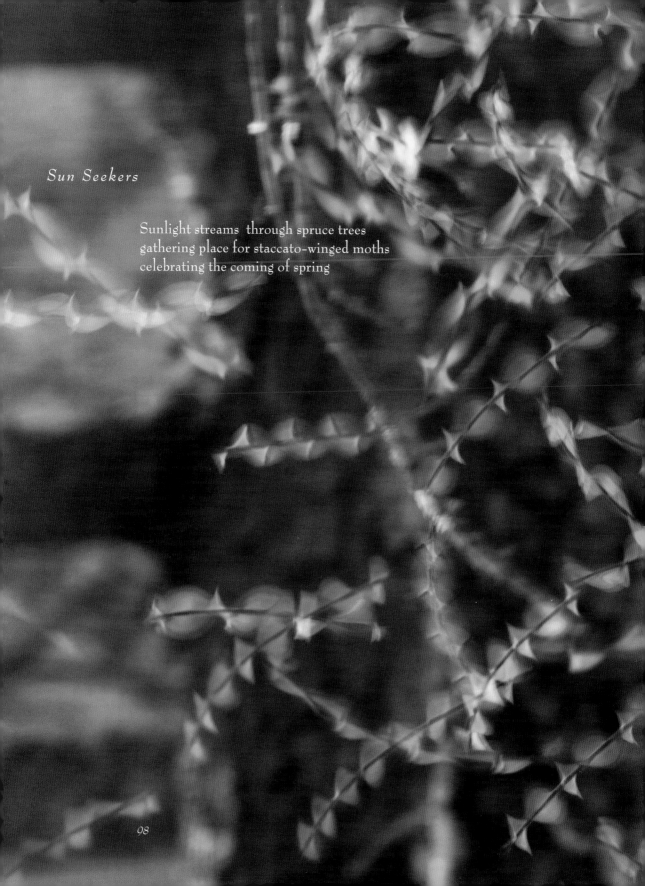

Sun Seekers

Sunlight streams through spruce trees
gathering place for staccato-winged moths
celebrating the coming of spring

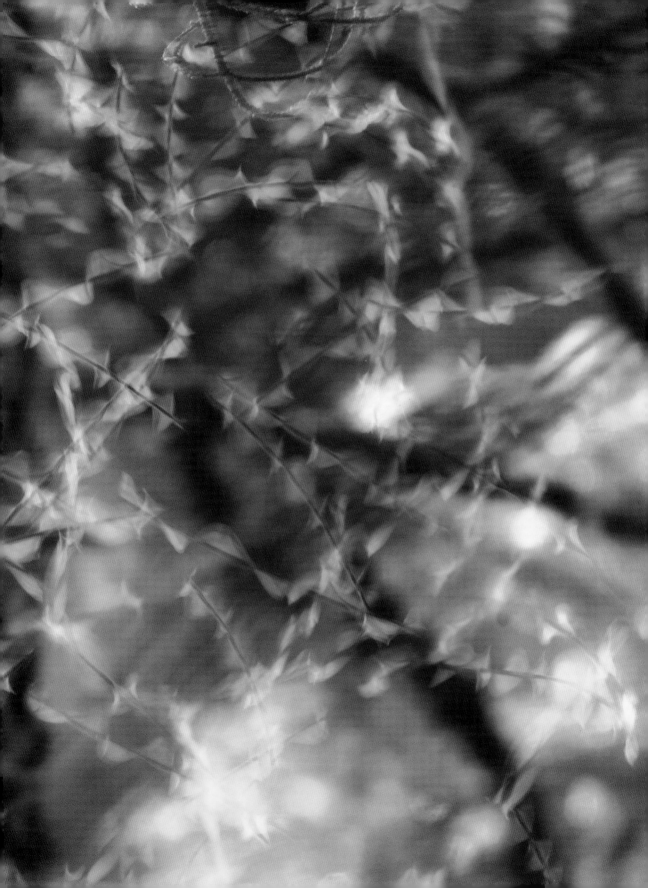

Spruce Gum

Nubs on spruce trees
snapped off, popped in mouth
first bite, bitter taste
softened by warm spit
slowly turns to gum
soft chew of younger days.

Spring waters bend
Reflected light, hugging grass
Monet painting in Maine

Choreography

A gentle breeze creates
a ballet of trembling light
pirouetting over the pond
glittering through the trees.

Territory

A loon couple is quietly feeding on the pond when a pair of mergansers fly in.
Mergansers, like loons, are fish-eating birds and not welcome on a small pond
inhabited by loons. As soon as the interlopers land, the loons go into a crouch and
begin stalking the mergansers. Like slinking wolves in a pack, they split up and
flank their foe. Once in position, they both submerge.

Moments pass as the wary mergansers swim anxiously back and forth hugging
the protective confines of the shore and clucking nervously, heads darting this way
and that searching for the loons.

The air is full of fearful anticipation.

Suddenly the water explodes as the aggressors attack from below with torpedo-
like beaks, instantly propelling the intruders onto the shore and then skyward.

As the mergansers fly away, the loons shake their ruffled feathers and give each
other a knowing look that unmistakably proclaims: OUR pond!

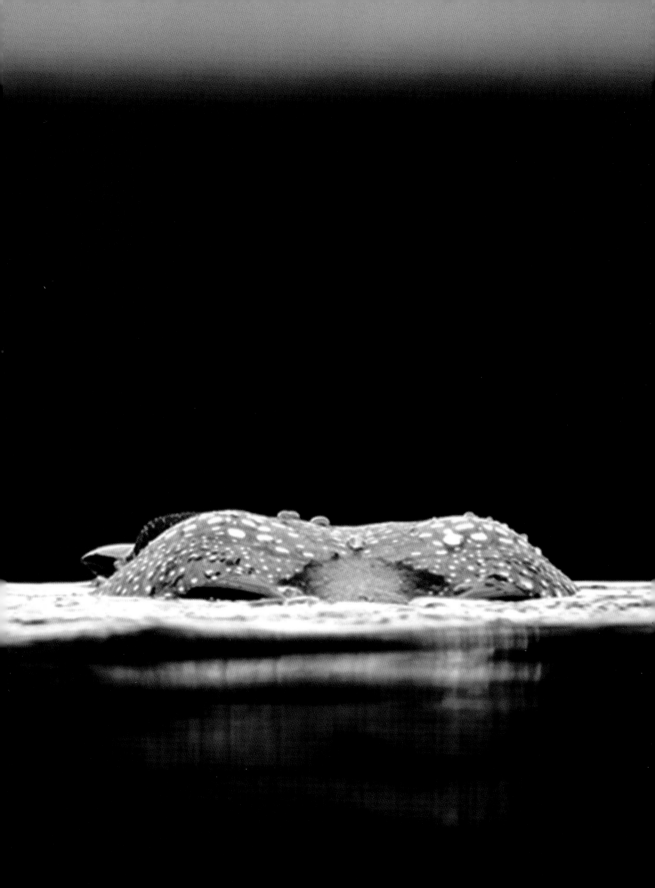

Mallard mother
Hastens fragile chicks away
Conducts fuzzy head count

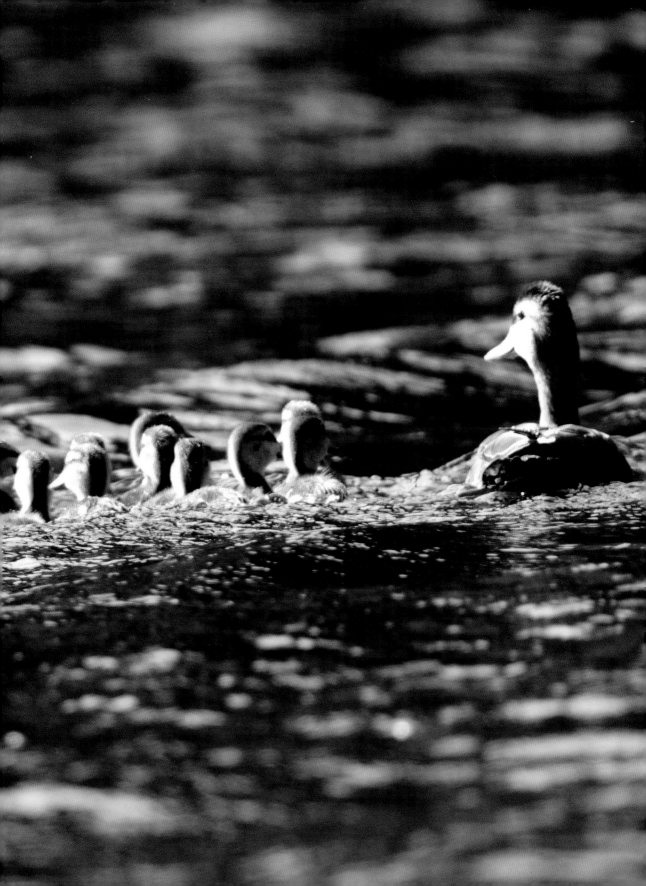

Chicks

Loons have nested on my pond seemingly forever, serenading me with their night-time calls, their lunacies, their affectionate gentle hoots and clucks to one another, as well as their sorrowful, lonely calls from pond to pond as if apologizing for some slight that drove them apart.

Each year, I wait for hatchlings to appear to no avail, due no doubt to predators roaming the grassy shores.

Perhaps that is why they left this year for the pond next door, even though its shores are less sheltered and more exposed to the sky, to ravens and hawks with sharp eyes for fuzzy loon chicks.

This morning the quiet was broken by a familiar call sounding like: "Made it here, take care of the kids, be home soon," something kind and reassuring to its tending mate beyond the ridge. Hard to tell with these strange birds what they are talking about and yet you know they are talking, no doubt of that.

Moments pass before I hear the sad lallulu call of the loon's mate, followed by a gliding black shape descending from the treeline and leaving a silvery V in its wake as it lands on the pond.

I say sadly, because a mother loon would never leave her chicks if indeed there were chicks to leave behind.

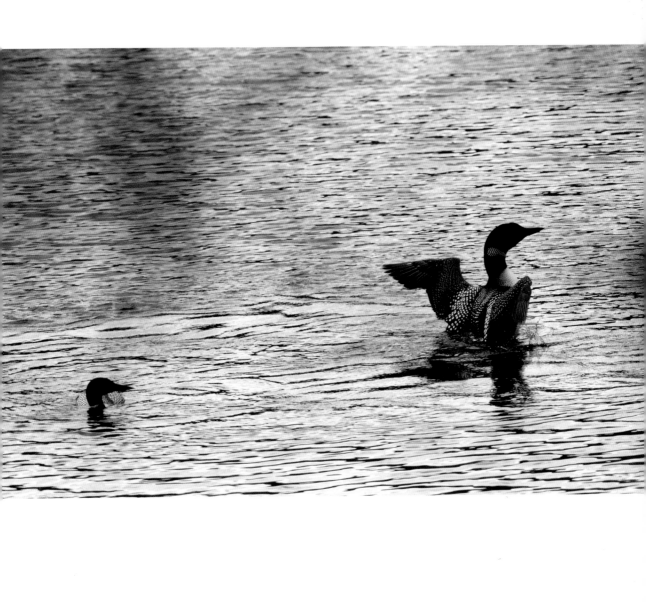

Capricious

A stately old-growth pine resides on the ridge along the trail to my camp. I give it a respectful nod whenever I pass by for it has survived the wrath of loggers in years past as well as the natural forces that shape life in the harsh and unforgiving woods.

The pine's massive girth is hidden by undergrowth
interlaced in a cluttered graveyard of
spruce, fir and hemlock woven around its base
a game board of Darwinian pick-up-sticks
of trees whose seeds were fatefully spread
by a capricious and uncaring wind.

A more telling view of the giant pine is from afar
where its signature is written against the sky
towering high above the ragged treeline
where the wind that landed its seeds on fertile ground
gently caresses its uppermost, outstretched branches
as a mother would caress her child.

Curiosity

Each evening
in the fading light
a shimmering V
makes its way
across the pond,
a beaver dropping by
a party crasher it seems
as it circles my cove
not quite sure
if it wants to partake
of camp festivities
or not.

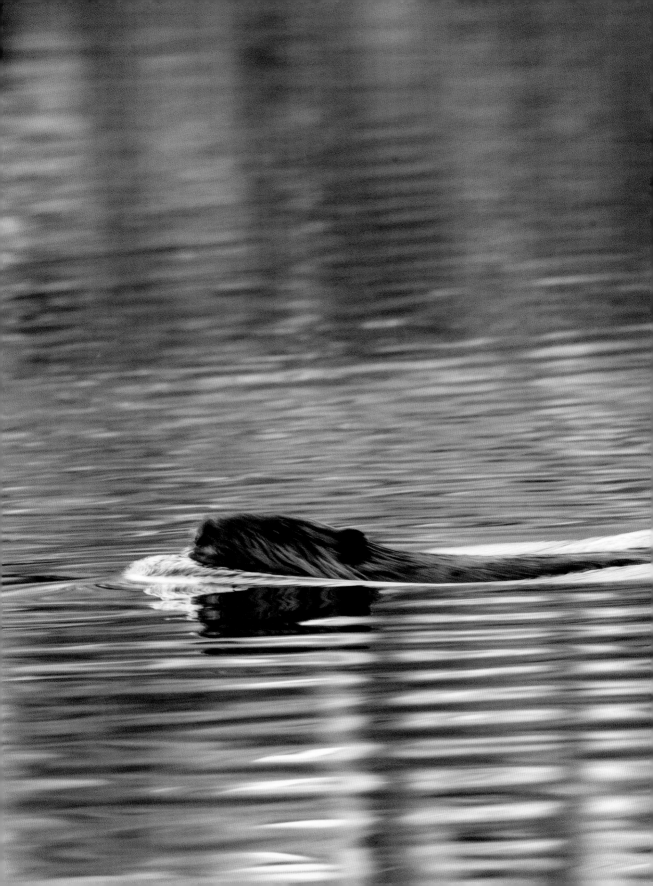

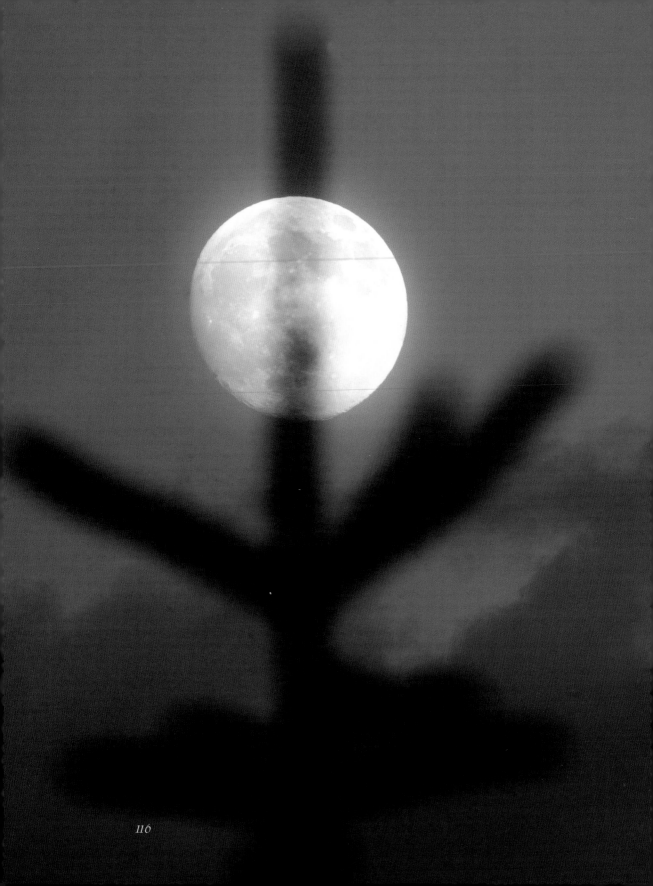

Full Moon

Full moon tonight.
Sunlight off lunar gray
paints the far shore
the faintest hint of day.

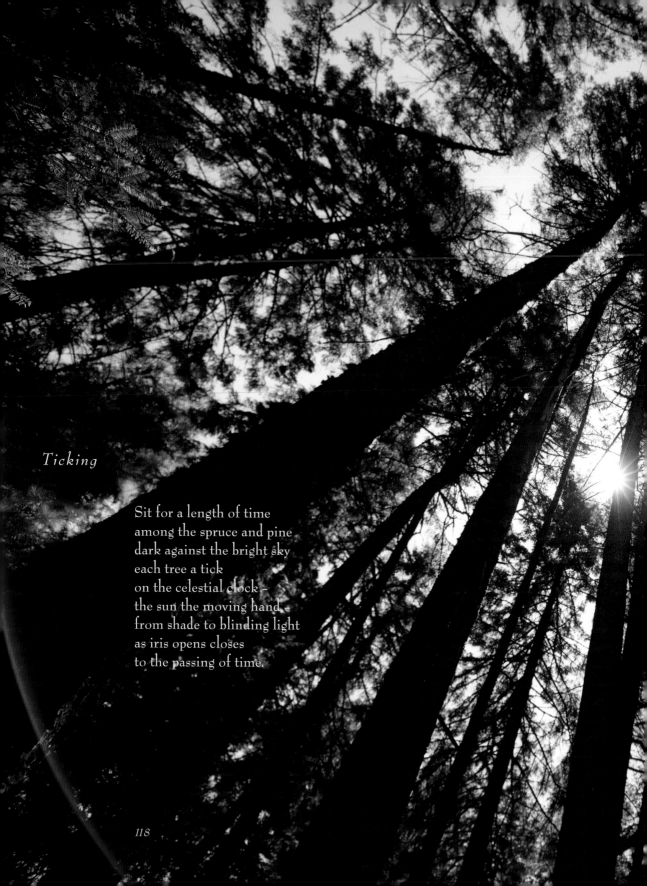

Ticking

Sit for a length of time
among the spruce and pine
dark against the bright sky
each tree a tick
on the celestial clock –
the sun the moving hand
from shade to blinding light
as iris opens closes
to the passing of time.

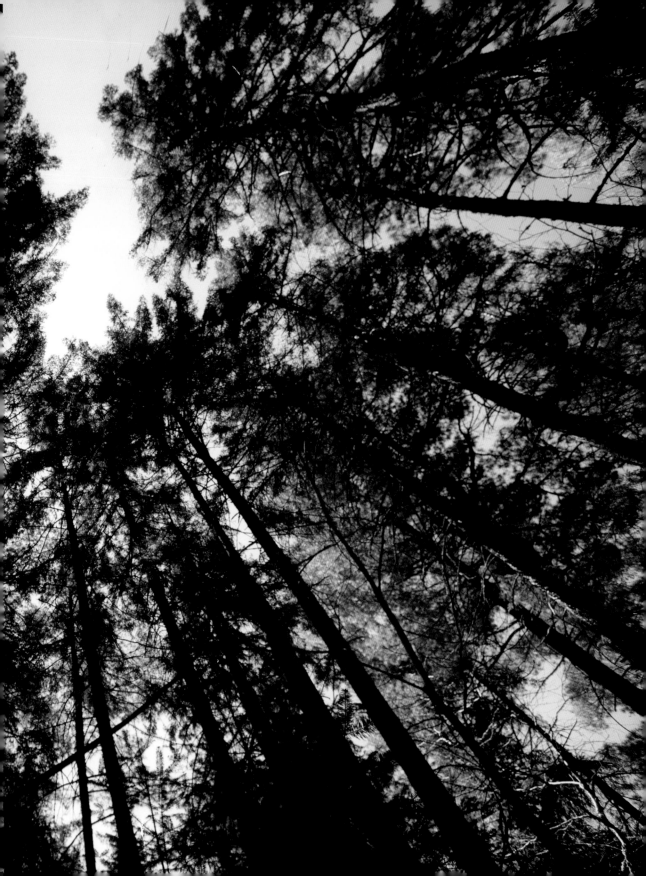

Deep Woods Robin

A robin in the deep woods
sings a song richer, more melodious
than that of its flatland cousin
whose passably inspired riff is sung
to the rising and setting of the sun
in urban parks or one's back yard;

a song

more beautiful, more complex, more like
Mozart's version of Salieri's minuet
nuanced, full of purpose, intent
a song of attraction in the dense woods
or perhaps sung purely for those of us
who assign motive to a bird song.

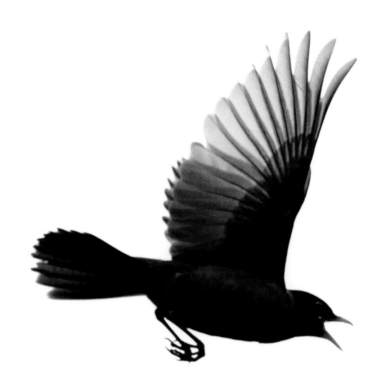

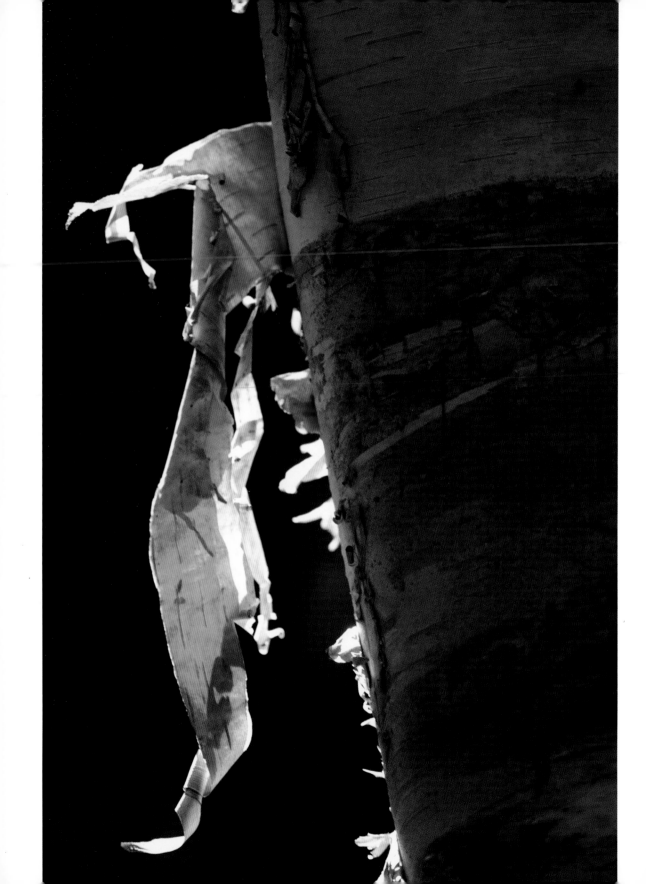

Birch

What is it that we love
about a paper white birch
in a stand of darkened spruce
made more radiant by
a shaft of late day sun?

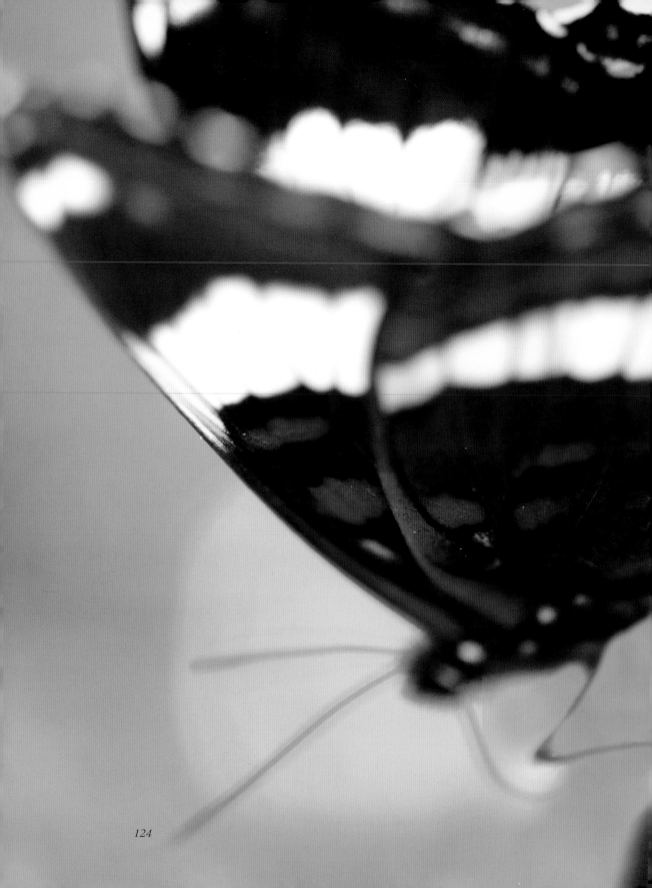

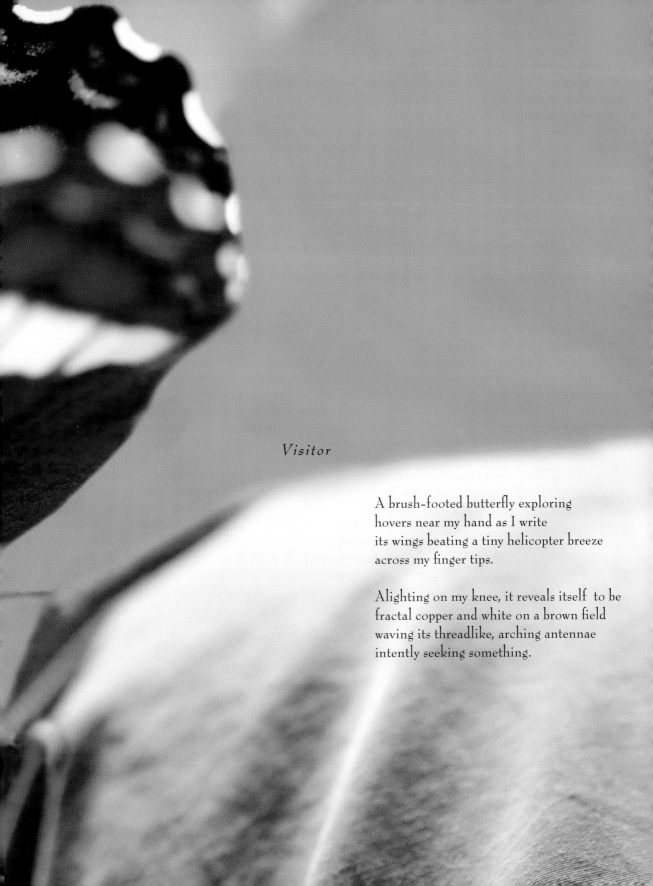

Visitor

A brush-footed butterfly exploring
hovers near my hand as I write
its wings beating a tiny helicopter breeze
across my finger tips.

Alighting on my knee, it reveals itself to be
fractal copper and white on a brown field
waving its threadlike, arching antennae
intently seeking something.

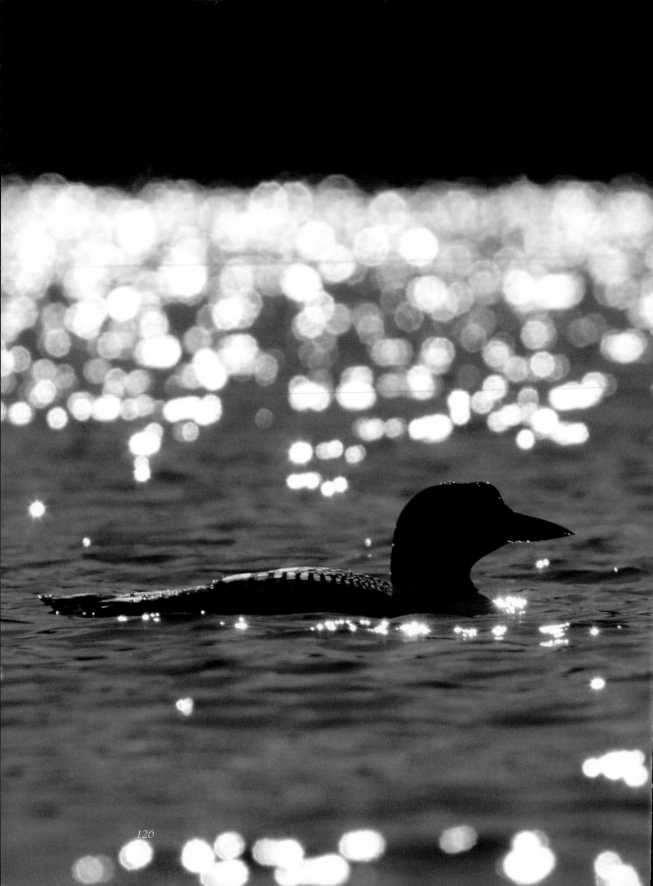

Alone

Loons have seven distinctly different calls
each with its own *raison d'être*
although I suspect no one knows for sure
what those *raisons* might be.

One is a poignant call in the dark of night
as two loons, having flown apart, converse
back and forth from pond to pond
in mournful tones, as if to say–"I miss you."

The lilting call of the hermit thrush
tumbles melodically through the woods
always from far away it seems, as though
the thrush is in hiding and wants only
to be known for its beautiful song.

An Oneida legend teaches the value of honesty to their children: Long ago the birds had no song. Only man could sing. Each day man greeted the rising sun with a song. The birds, as they flew by, listened to the beautiful song and they wished they too could sing. One day the Creator visited the earth.

The Creator walked around on the earth looking at all the things he had created. He noticed, though, that there was a great silence. Something was missing.

As the Creator thought about this, the sun sank behind the western hills. Then he heard the distant sound of a drum followed by the chanting of the sunset song. The sounds pleased the Creator.

When the Creator looked around, he noticed that the birds were also listening to the singing. "That's what's missing!" said the Creator. "Birds should also have songs."

The next day the Creator called all the birds to the great council. The birds came from far away. The sky filled with flying birds and the trees and bushes bent under the weight of so many birds.

The Creator sat on the council rock. The birds perched and became quiet. The Creator spoke.

"Would the birds like to have songs and be able to sing as the people sing?" With one voice, the birds replied, "Yes! Yes!"

The Creator spoke to them. "At tomorrow's dawn, fly as high in the sky as you can. When you can fly no higher, it is there where you will find your song. The bird who flies the highest will find the most beautiful song."

The next morning, all the Creator's birds gathered upon the land. Excitement spread throughout the birds. One small brown thrush was not excited. He was perched next to a great eagle. He looked at the strength of the eagle and thought to himself,

"What chance do I have of reaching the most beautiful song? This eagle is so great. I will never be able to compete with a bird such as he."

The eagle, eager for daybreak, took no notice of the small brown thrush near him. The thrush had an idea. The thrush flew to the eagle's head and quickly hid beneath his feathers. The eagle stretched his wings. "With my great wings, I will surely fly to the most beautiful song."

At that moment, the first break of dawn appeared. With a great roar of wings, the birds took off. The morning sky remained dark as so many birds flew up higher and higher.

The first bird found his song. He had flown so hard you could hear a hum coming from his wings. The hummingbird song plainly calls, "Wait, wait for me." Next the cowbird tires, and as he flies down to the earth, he sees other birds weaken and find their songs.

The sky began to darken once again. As the sun went down behind the horizon, only the Eagle, the Hawk, the Owl, the Buzzard, and the Loon flew higher.

As daybreak came the next day, only Eagle, the chief of all birds, was left. He flew steady and strong until the sun was halfway in the sky. He looked and saw he was the only bird left in the sky. He began triumphantly soaring to the earth. The thrush awoke from his sound sleep at the back of eagle's head. He hopped off the eagle's head and began flying upward. The eagle saw the thrush begin his journey, but was exhausted. The eagle could do nothing more than stare at him in anger.

The little thrush flew higher and higher. He soon came to a hole in the sky. Entering the hole, he heard a beautiful song coming from the Spirit World. He stayed and learned the song. When he had learned it perfectly, he took leave of that place and returned anxiously to earth. He could not wait to share this most beautiful song with the others.

As he came closer to earth, he could see council rock, and he could see the great eagle, Stagwia, waiting for him. All the other birds waited in silence for thrush's arrival upon the earth.

The thrush, nearing the earth, no longer felt proud of his song. He began to feel ashamed that he cheated to find this song. He feared Stagwia, for he was the one thrush cheated out of the song. He flew in silence to the deep woods. He hid in shame under the branches of the largest tree. He could not proudly share his song. He was so ashamed that he wanted no one to see him.

There you will find him even today. The Hermit Thrush never comes out into the open because he is still ashamed that he cheated. Sometimes, he can't help himself, though, and he must sing his beautiful song. When he does this, the other birds stop singing because they know the song of the Hermit Thrush is from the Spirit World. That is why the Hermit Thrush is so shy and that is why his song is the most beautiful song of all the birds.

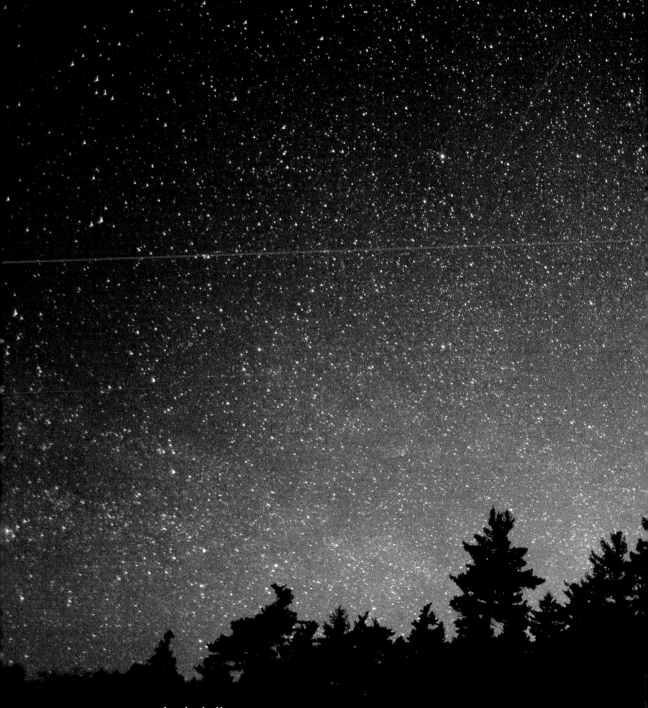

Night sky ballet
Points of starlight dancing to
Attentive audience

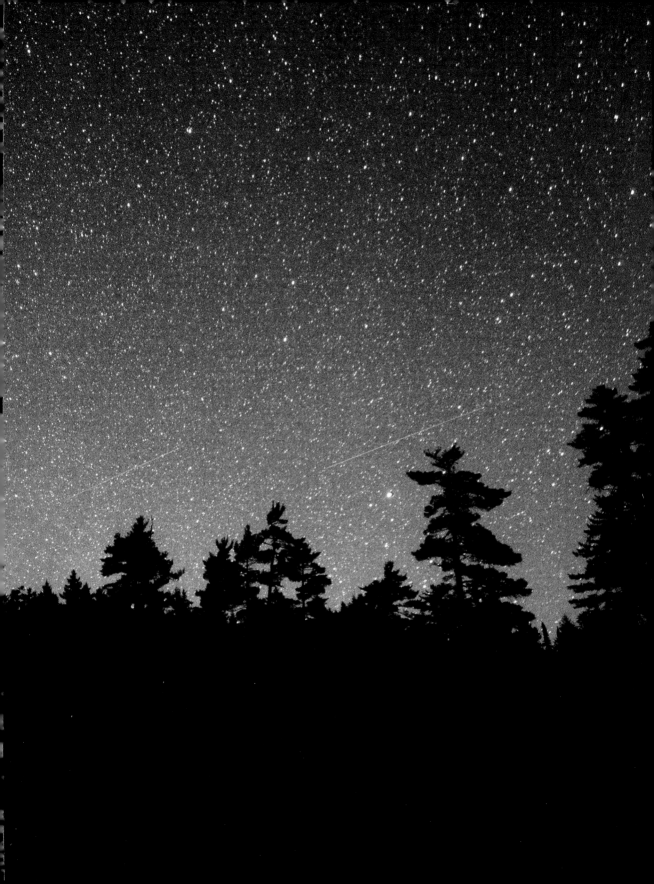

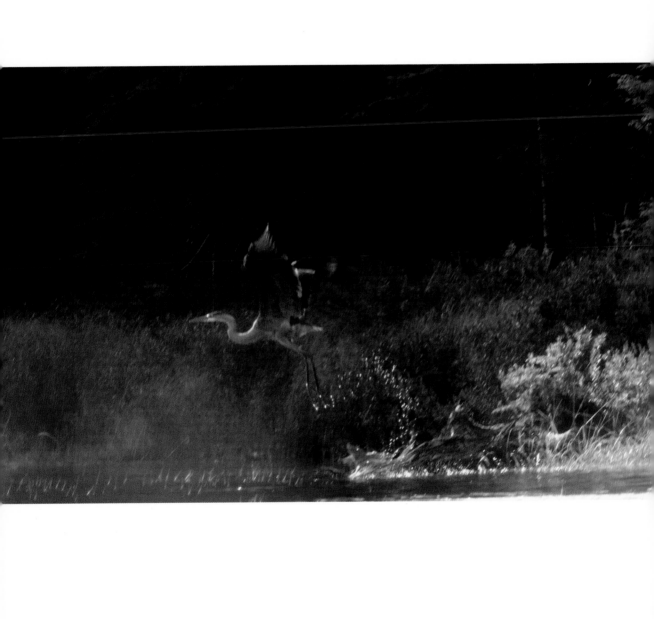

Great Blue rises
Water droplets float in air
Leave signature in flight

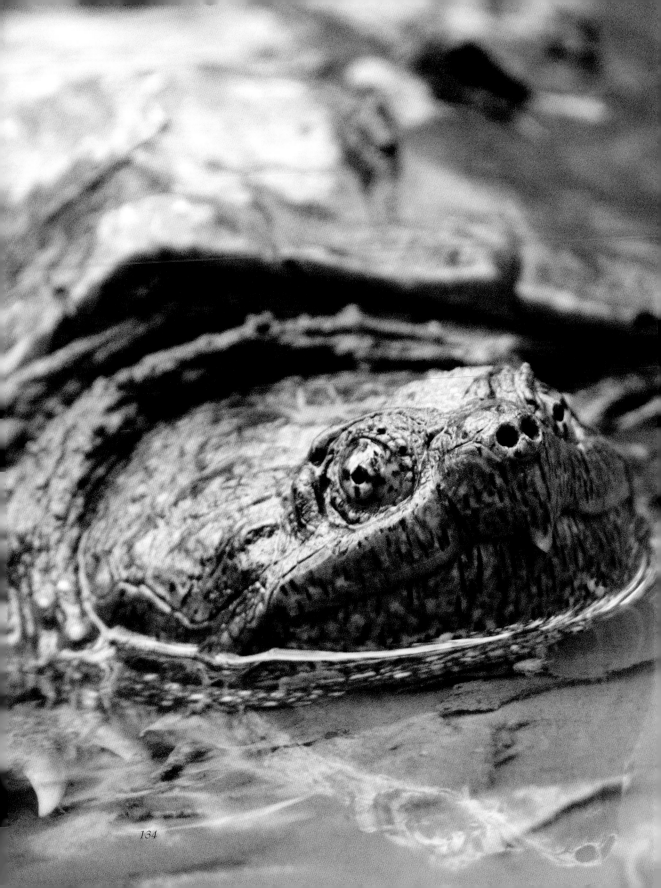

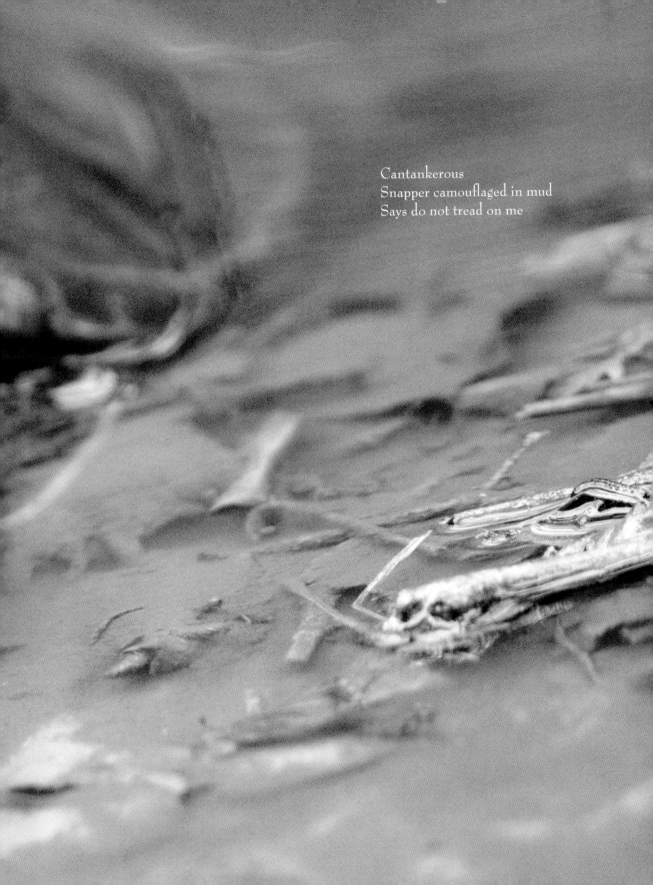

Cantankerous
Snapper camouflaged in mud
Says do not tread on me

I am sitting along the shore with my back against an ancient pine listening for beavers talking in their lodge. It's a barely audible sound if it can be heard at all, but on this day the distant drone of logging skidders working the land to the west is pulsing on the wind, interrupting the gentler voice of the spring woods.

As I am about to pull up stakes and leave,

a song sparrow flies in, begins to sing
a prelude for an ensemble of local voices

A light breeze rattles delicate birch leaves
notes of shimmering green among dark firs.

A mallard pair weaves in and out of reeds
creating a whisper of feathers on grass.

Red squirrels seeking seed-filled cones
leave tiny rustlings on the forest floor.

Staccato trumpets sound from up the pond as
loons perform a frenetic mating dance.

Rippling pond water adds harmony -
rhythmic rapping on the windward shore

and as if on cue

beavers join in from within their lodge
adding loving lyrics to nature's orchestral score.

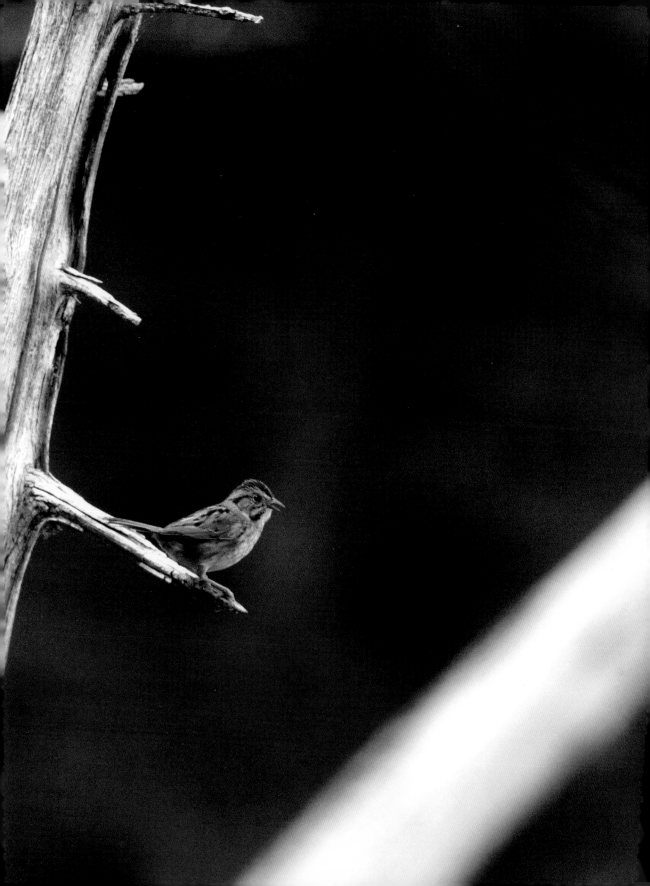

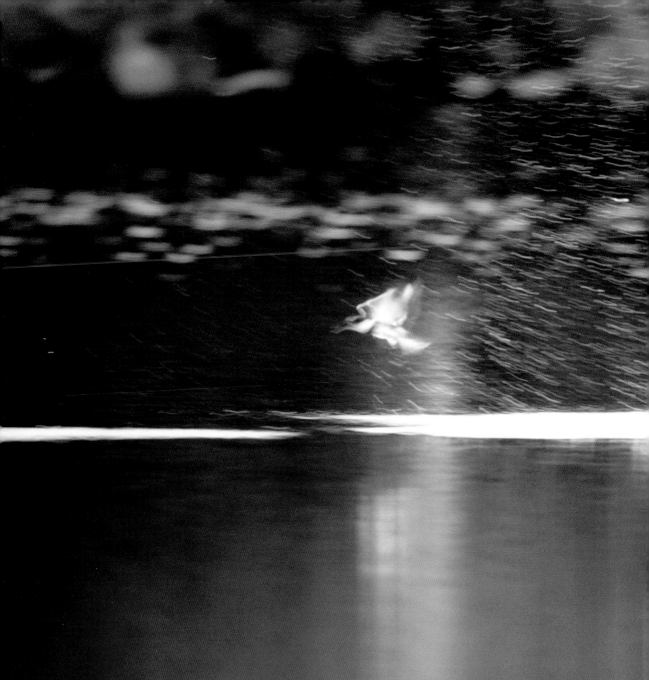

Kingfisher

Nervous wreck of a bird,
incessantly chittering as it
flits from branch to branch
surveying shallow coves
in search of careless minnows
swimming too close to sky.

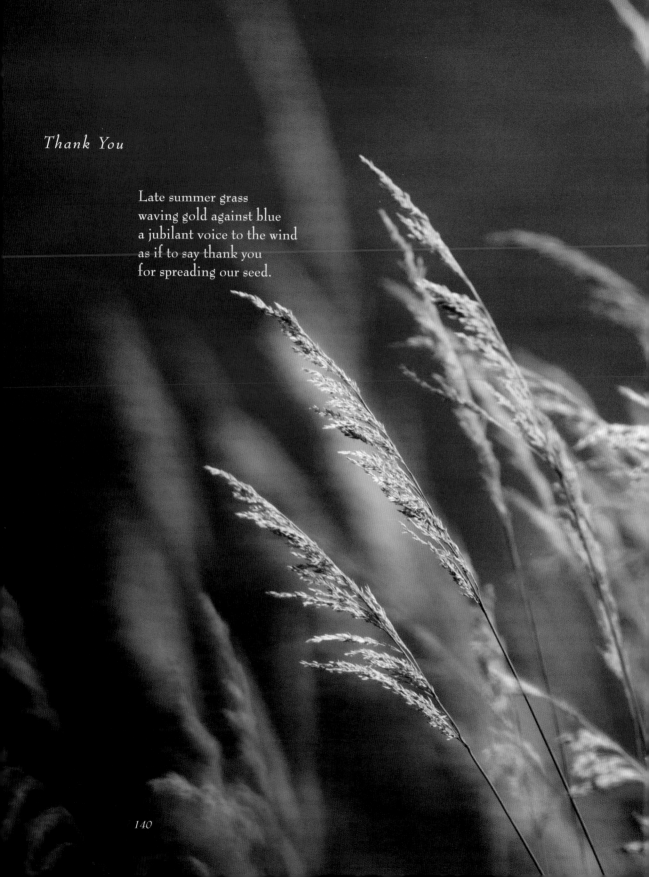

Thank You

Late summer grass
waving gold against blue
a jubilant voice to the wind
as if to say thank you
for spreading our seed.

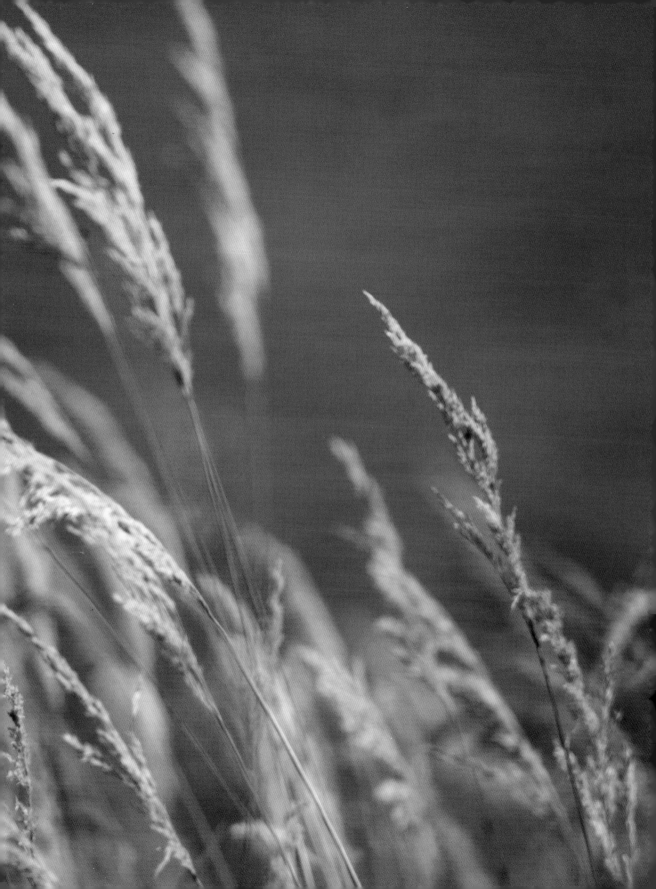

The Gift

The sun's rising arc
follows me without notice
until one evening late in May
I see before me
the gift of longer days.

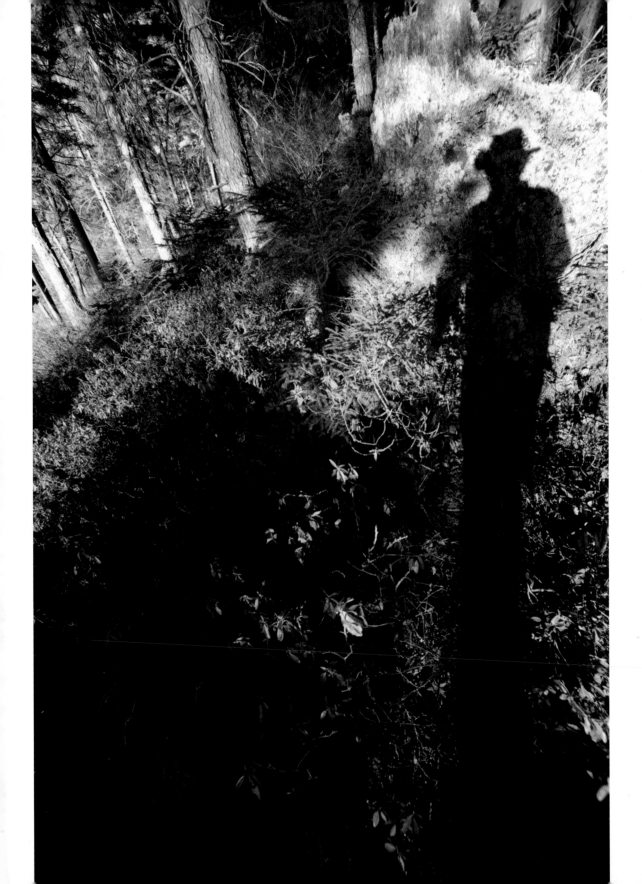

Acknowledgements

I sometimes refer to the camp that is central to this book as "my" camp, when in fact I owe its existence to numerous friends and relatives. I am deeply indebted to them for helping me build it in a nearly inaccessible location, the last half mile of which is a brutal slog through rough terrain and some of the most formidable mud holes in the Maine woods.

My older brother, Steve, had a camp on a nearby pond for a number of years where I spent many happy hours. Steve has since died and there is never a time when I am in the woods that I don't miss him.

I greatly appreciate my sister, Susan, for providing room and board on those days when I could not get to camp, my brother, Rob, for doing a lot of the heavy lifting and my fishing buddies, Craig Nelson and Bob O'shaughnessy, for sharing so many great camp experiences.

I especially want to thank my wife, Peggy, who held the family fort and dealt with all the home and family responsibilities while I was sitting on a comfortable stump contemplating the natural world around me.

I am also indebted to Peggy for her perceptive editing and her great feeling for poetry. My granddaughter, Caroline Sonier, also provided editing help.

Thanks to bird enthusiast, Kristen Lindquist, for identifying birds in the book. The Oneida legend about the hermit thrush came from Indianlegend.com.

I would be remiss if I did not thank Roxanne Quimby for creating the nature sanctuary in which I was able to photograph and write so peacefully. Her commitment to restoring much of the Maine woods to its natural state has been a controversial journey to say the least, but I have nothing but respect for all she has tried to do. Her son, Lucas St. Clair, has taken over the reins and deserves great credit for encouraging local use of the land.

Baron Wormser wrote a very nice review for the book and for that I am deeply grateful, especially coming as it did from such an accomplished writer and poet.

If there is life after a book, for me it will be to immerse my grandchildren in the natural world and the joys of camp life so they too may one day walk in the woods and listen for the quiet whisper of living things.

Michael Weymouth
2014

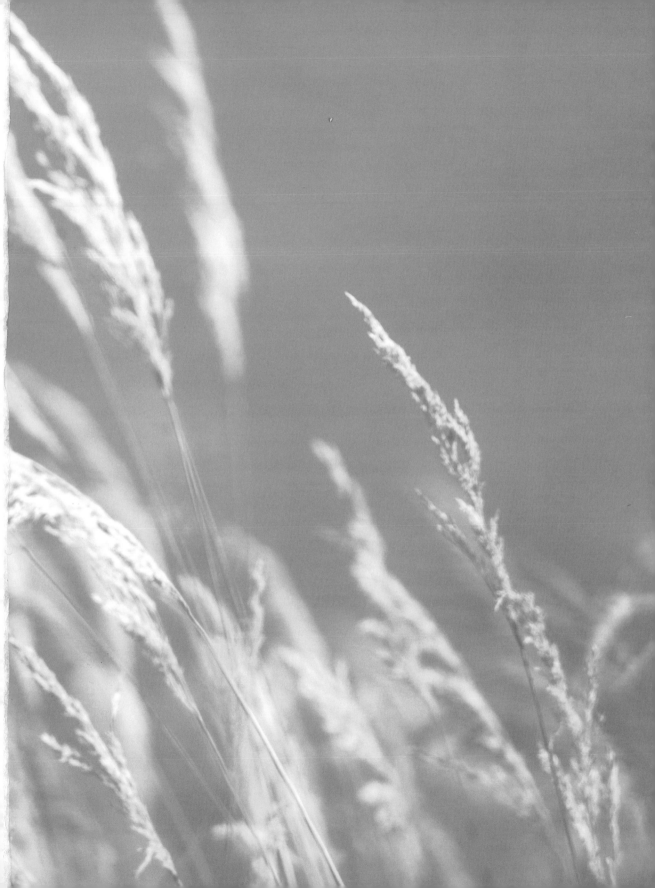

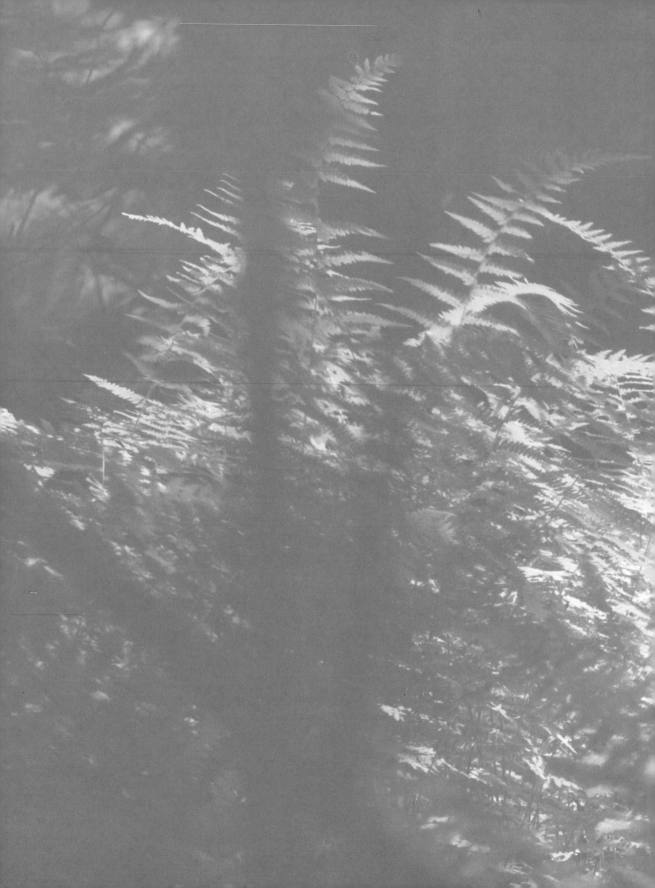